Get Up &
Gouache

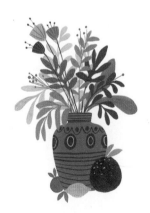

Thunder Bay Press
An imprint of Printers Row Publishing Group
10350 Barnes Canyon Road, Suite 100, San Diego, CA 92121
www.thunderbaybooks.com • mail@thunderbaybooks.com

Correspondence regarding the content of this book should be sent
to Thunder Bay Press, Editorial Department, at the above address.
Author, illustration, or rights inquiries should be addressed to Ilex Press,
Carmelite House, 50 Victoria Embankment, London, EC4Y 0DZ, UK.

Thunder Bay Press:
Publisher: Peter Norton
Associate Publisher: Ana Parker
Editor: Traci Douglas
Product Manager: Kathryn C. Dalby

Ilex Press:
Publisher: Alison Starling
Editorial Director: Zena Alkayat
Managing Editor: Rachel Silverlight
Junior Editor: Stephanie Hetherington
Editorial Assistant: Ellen Sandford O'Neill
Art Director: Ben Gardiner
Designer: Sarah Pyke
Assistant Production Manager: Lucy Carter

ISBN: 978-1-64517-058-7

Printed in China

23 22 21 20 19 1 2 3 4 5

Get Up &
Gouache

Unleash your creativity with 20 painting projects

Jessica Smith

THUNDER BAY
P·R·E·S·S
San Diego, California

Contents

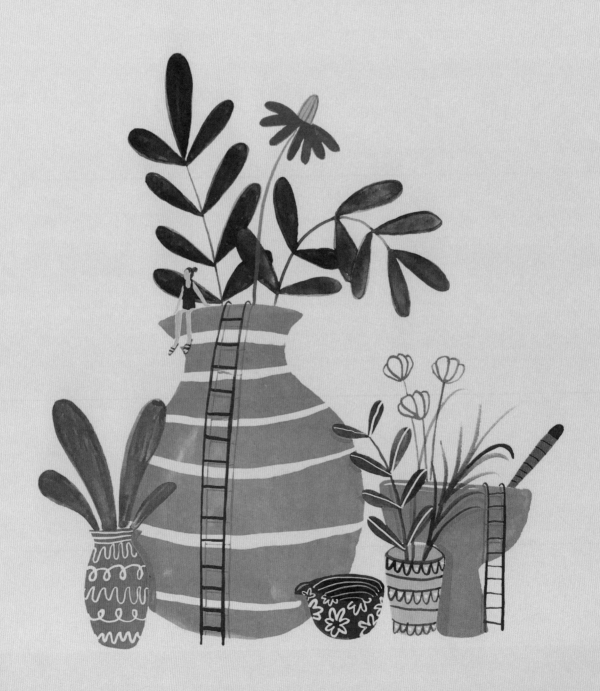

Introduction

My love of gouache all started at university. I had always loved painting and I had experimented for a long time with watercolors and acrylics, but they never quite worked for me; watercolor never managed to give me the vibrancy of colors that I wanted, and acrylics didn't give me the finish I was looking for. As I began to develop my illustration style and settled on a playful, bold look, I needed a medium that would allow me to achieve the bright colors and matte finish that I desired in my work. This was when I found gouache. I fell in love with the huge array of colors and the chalky finish that gouache has on the page when dry.

During my time at university, I found myself painting almost everywhere, so I always had my paints with me. Gouache is brilliant for painting on the go, as it is small enough to be transportable, is easy to set up, and dries quickly so that you don't have to wait long before packing up and moving on.

Gouache's fast drying time is great for day-to-day work, as I can quickly move on to the next layer of the painting or the next piece. Gouache also photographs really well, which is ideal in our digital age. Working as a full-time illustrator means that I need to take a lot of photographs of my work and gouache's flat, matte surface means there is no light glare from the paint.

In this book, we will explore all the different techniques of gouache and the fun and playful ways that it can be applied to the page. We will cover the basics of color theory to help you understand how to mix properly and the science behind great color selections. The projects start with simple exercises to ease you in, then become increasingly more challenging. We'll look at pattern, portraits, animals, and everyday scenes and objects. By the end of the book, I hope that you will be able to establish your own way of working with gouache and fall in love with the medium, as I have!

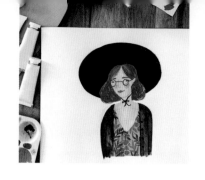

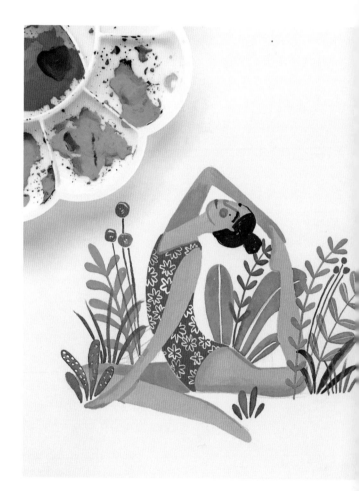

Materials

Brushes

The best paintbrushes to use for gouache are a matter of personal preference. Because both watercolor and gouache are water-based paints, any paintbrushes recommended for watercolor will work just as well for gouache.

The important thing is to have a range of sizes and shapes, including flat and round brushes. I always like to have a wide range of brush sizes to hand while I paint so that I can switch between them as I need. I tend to use synthetic brushes for my work as they carry color well and are perfect if you're on a budget or just starting out. I also find that synthetic brushes have a much better point than natural brushes, meaning that delicate work is much more achievable. I recommend having a mixture of soft and stiff bristles to allow you to create a range of looks and textures with your brushstrokes.

I tend to wash my brushes after I finish a piece of work. Unlike acrylics or oils, gouache won't ruin your brushes if you leave them dirty, so you don't need to thoroughly wash them every time. Because gouache is water based, you just need to pop it under the tap and the color will begin to rinse off; move the brush around on the bottom of your sink, spreading out the bristles. If you want to thoroughly clean your brushes, use a bar of mild hand soap or a special brush-cleaning soap. To use this, just wet your brush and sweep it around in a groove in the soap, then rinse the brush off and repeat until you've removed the color. You only need to clean your brushes this way once or twice a year.

It's also a good idea to keep paper towels at hand while you're working, so that you can wipe your brushes between switching colors. This helps with any unwanted color transfer and is a good indicator of whether you have removed all of the color.

You do need to look after your brushes, so try not to leave them sitting in your water pot as this will slowly break down the glue that holds the bristles in place, and they will start to drop out. The weight of the brush being upside down for a long period of time will also ruin the shape of your bristles.

Paints

As with brushes, there is no "correct" brand of paint to use—it's all down to personal preference. Personally, I like to use a more expensive brand of gouache for its good quality and beautiful range of colors. Gouache can be expensive, so if you can't afford many paints, I recommend starting off with just three basic primary colors plus a tube of white and a tube of black. From these, you can make all the colors you'll need until you find your feet and want to invest in some new, fancier colors. Alternatively, there are some cheap store-brand multipacks that are perfect for starting out until you can afford better-quality paint. There are many brands out there, so definitely do your research before you buy your first set. Saying that, there is nothing wrong with mixing brands, so maybe try one from each to see which you like best!

To store your paints, just make sure that you keep the lids sealed tightly to avoid any air getting in. If air does manage to get in or you forget to put your lid back on, don't worry—because gouache is water based, it can be rehydrated if necessary. Simply cut open your dried-up tube, add a little bit of water and you're ready to go. If ever you can't remove a lid because it's too tight or has been glued shut with paint, try running it under hot water for a minute to loosen it up.

Palettes

I use a little white plastic palette for my paint; I find this the best as it is very affordable, easy to clean, and light to carry around with you. They often have little wells for you to mix your paint in, which will help to keep all of your colors separate from one another. If you are going to use a flat palette, be sure not to tilt it as the water from your paints will likely drip off.

Pencils

A lot of artists like to sketch out their designs before they begin painting, as it helps them to feel more confident with the application of the paint. Choose a pencil that isn't too dark, as you don't want the graphite to mix with your paint or show through. I like to use a 2B pencil so that the lines are just dark enough to see but light enough to be easily covered by the paint. I wouldn't go any darker than this, although you can certainly go lighter if your eyesight is up to it.

Paper

Gouache applies pretty well to most papers because it sits on the surface and doesn't soak in like watercolor. I use a fairly heavyweight paper (148lbs/220gsm), as I prefer the feel and finish. I also use paper that doesn't have a huge amount of texture (tooth), as this tends to show through the paint. Saying that, watercolor paper actually works well for gouache.

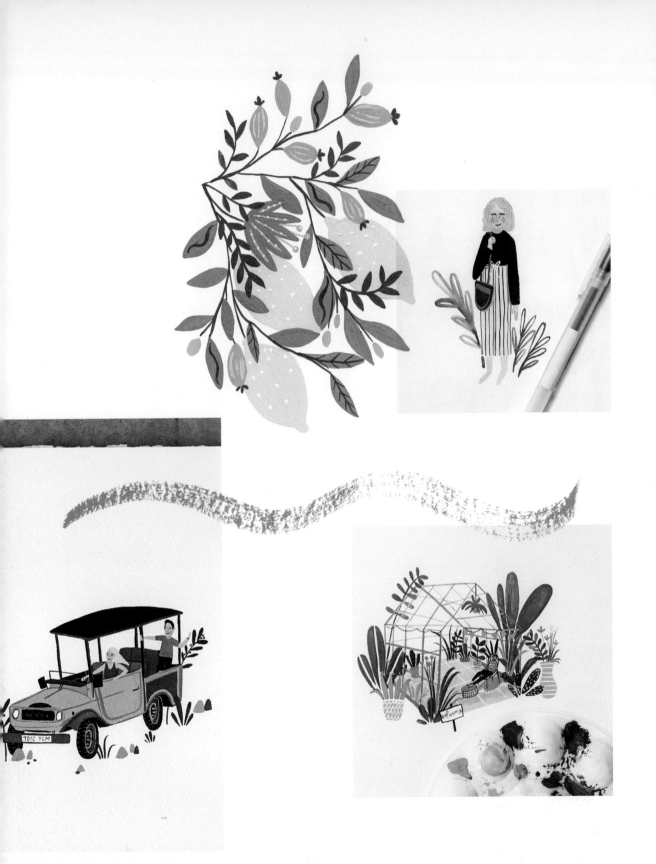

Techniques

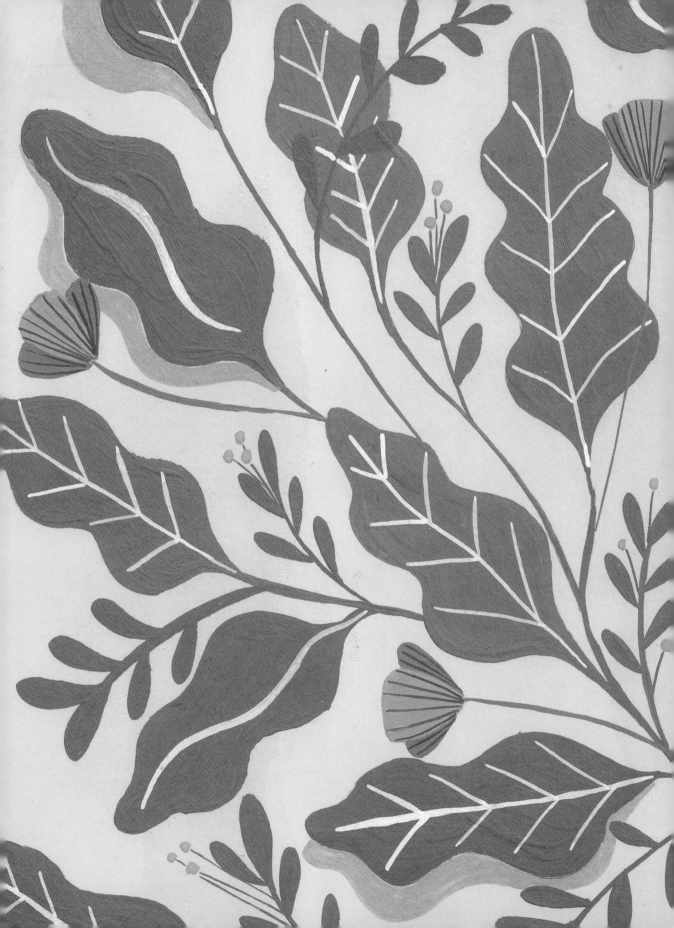

Layering

PERFECT FOR

Landscapes
Busy scenes
Patterns
Highlights

Opaque layers are the thing that gouache is best known for and the reason I love working with it so much.

As with watercolor, gouache can be altered at any time—no matter how dry the paint is—by adding water. Therefore, to avoid your colors mixing when you're applying layers, you should make sure that the layer beneath is fully dry, use a light hand to avoid disturbing the paint below, and apply a generous amount of paint to your brush so that it glides on smoothly in one stroke—the more you work the paint, the more likely it is that your colors will merge.

It's always easier to work from light to dark, but unlike watercolor, if you need to, you can also work from dark to light—that's what's so great about gouache. When working from dark to light, use thick layers of paint to cover up the darker color below. This means that you can layer any colors you like, which is useful if you want to paint on a colored background.

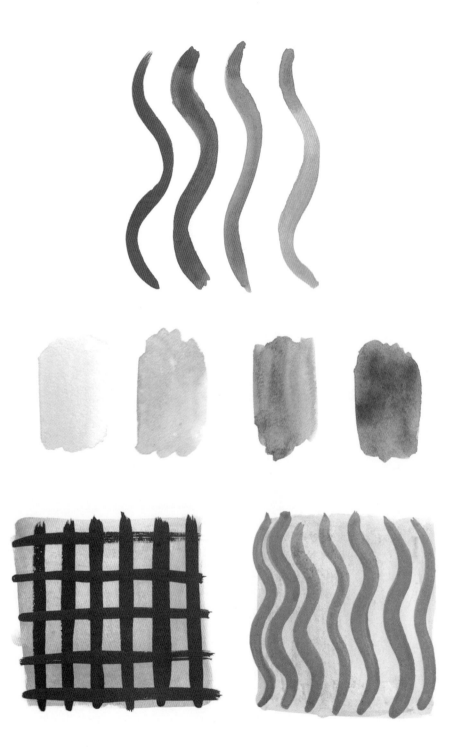

Staining

PERFECT FOR

Landscapes
Underwater scenes
Backgrounds

Staining allows you to cover a large area with watered-down gouache to provide a colored background, on which you can then paint your main subject. When using this technique, you are treating gouache as if it's watercolor paint. I find it a good idea to stain a background when I am going to be painting lots of foliage or details on top. As you can see from the bottom images opposite, you can layer another color on top of a stain effectively.

To stain your page, mix up a color with a generous amount of water, then using a wet brush, pick up your color and apply it in even strokes across the area you wish to cover. I recommend using a large brush for this as it allows you to apply the paint much more quickly, so that it doesn't have a chance to dry and form hard edges before you're finished. Using a large brush will also help the layer of paint look more even and uniform; anything from a size 4 to 8 brush will work perfectly. You may also want to stick your page down with low-tack masking tape onto a board or an easy-to-clean surface, so that you can make big sweeps of paint off the edge of the page to get an even finish down the sides.

The staining technique takes a long time to dry, so if you wish to blend and move the paint around, there is plenty of time to do this. However, it also means that you need to be careful not to let different sections of color blend into one another unintentionally.

The amount of pigment to use is completely up to you: either go for a really light wash or something darker. The lighter you want the color to be, the more water you need to add to your paint.

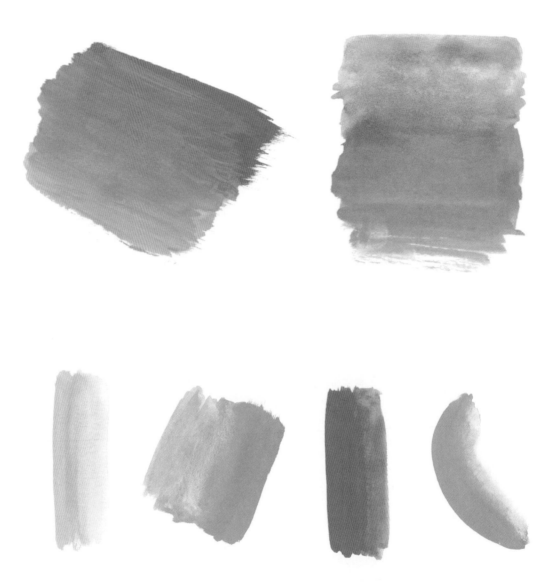

Blending & Softening Edges

PERFECT FOR

Skies
Sunsets
Water
Landscapes
Petals and leaves

Blending gouache colors on the paper is a great way to add extra colors to your work. It allows you to create subtle transitions from one color to another, and it is ideal for paintings of sunsets, cloudscapes, or even a choppy sea.

Be mindful that you do need to be sure what color you'll get. For example, you know you'll get orange if you mix red and yellow, and you know you'll get green if you mix blue and yellow. The last thing you want is a big brown smudge from mixing together colors from opposite sides of the color wheel. If you're not sure, do a test on a scrap piece of paper.

To blend two colors, paint a section of the first color and let it dry a little before applying the second color right next to it. Then begin to merge the colors together with your paintbrush—you'll see how easily they blend.

You can use the same technique using just water in place of the second color, to lighten a color that is too dark. However, you won't be able to get back to the pristine white of the unpainted paper as some pigment will inevitably remain, staining the paper.

Softening edges is very similar to blending, but instead of adding another color, you just add water. Softening the edge of a dried paint stroke is easy because gouache is water based. Simply load up your brush with water and apply it to the edge you wish to soften. You'll see the paint begin to dampen again and you'll be able to move it around, or even lift off some of the pigment, and make the edges look much paler and softer. This technique is great for paintings things such as clouds.

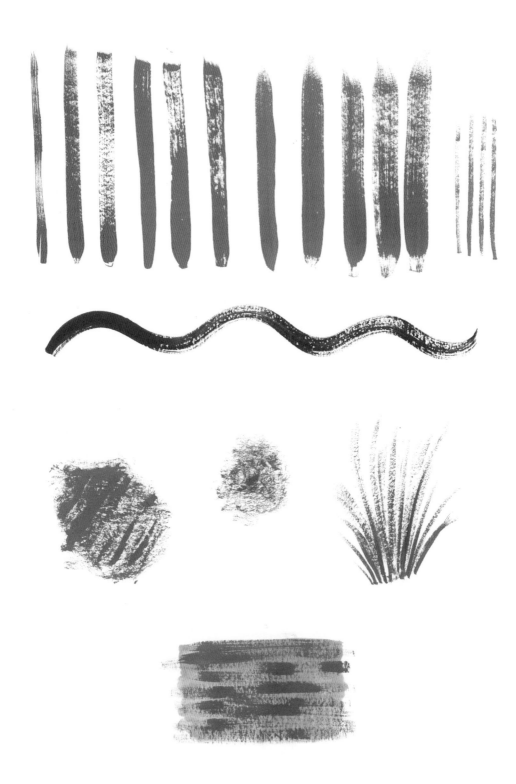

TECHNIQUES

Drybrush

PERFECT FOR

Hair and fur
Clouds
Clothing
Rough textures

Gouache is known for being opaque and flat, so the drybrush technique is a method of adding texture and interest to your work.

When using this technique, not only do you want to use a dry brush, but you also want to keep your paint fairly dry, so don't add much water. As you mix the paint, you'll notice that it feels quite sticky without adding water; this is the perfect consistency. You only want a little on the brush—it's often a good idea to wipe off any excess on the side of your palette or on a piece of paper towel before you apply the brush to the paper—and you can even splay out the bristles of the brush with your fingers to enhance the effect. The paper also needs to be completely dry for this technique; if you drybrush on top of a damp wash, the paint will spread into the damp area and you'll lose the effect.

Painting with drybrush is spontaneous, as every stroke will look different from the others. This is ideal when you are painting hair or fur because it makes it look more organic. You can experiment with a range of different brushstrokes; if your character has wavy or curly hair, you can apply the paint in wiggly lines, as shown here. If you want to get a fluffy effect, use a soft-bristled brush; if you want to create wiry, coarse hair, then use a paintbrush with harder or thicker bristles.

As well as individual lines, you can also use a large brush to create whole areas of texture by using very little paint and dragging the dry brush across the page. This is particularly effective when you're trying to create a sense of texture without painting individual lines, and it's useful if you're painting grass or a rug. You can also use this technique to create a background that you can then paint on top of.

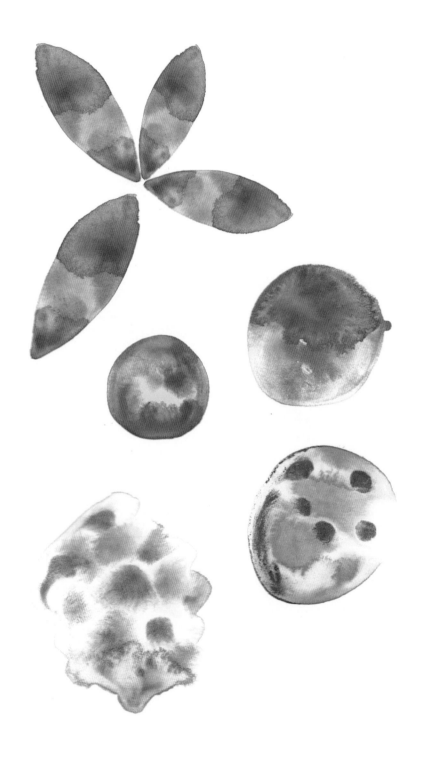

TECHNIQUES

Blooming

Flowers
Leaves
Multicolored shapes

Blooming involves using very watered-down pigments to create wishy-washy effects. Blooms can be used to paint a pale base color that you can then paint on top of when dry, which might be useful for a sky or sea scene. You can also use this technique to paint a specific area with lots of different colors that flow and blend together.

To paint a watery base color, paint the area you want to fill with water, and then gently apply a small amount of pigment to the area; the pigment will "bleed" and spread over the damp paper.

Similarly, to apply a range of colors, load up your paintbrush with a lot of water and brush it over the area you'd like to fill, then dab on your different colors and watch as they move and bleed into the water and each other.

With this technique you can still create precise shapes, as with the flower petals shown here, because the paint will not spread beyond the wet area of paper. With practice, you'll get better at judging how damp the paper needs to be to create the effect you want.

As you can see from the examples, the edges that you achieve with blooming are much softer and more organic than those you get when painting normally. As the paint dries it creates a blurred edge, which merges with the other colors. (In fact, blooms are sometimes referred to as "cauliflowers" because of the rather knobbly, irregular-shaped edges that you get when the paint dries.) The results are a little unpredictable, but that is part of the charm—and it allows you to achieve some really interesting effects that look much more like watercolor than gouache.

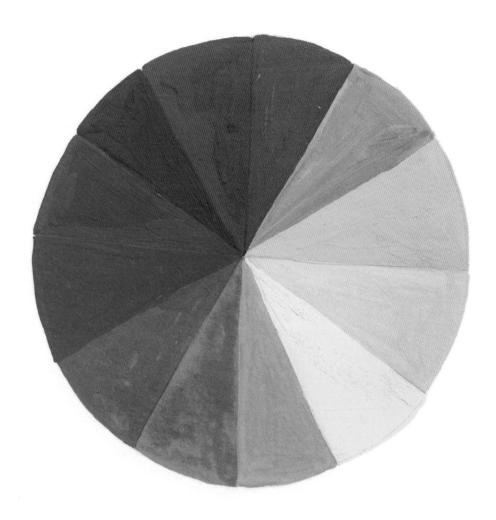

TECHNIQUES

Understanding Color

If you've ever admired the work of an artist or designer and wondered how they've picked their colors, it's likely that they've used color theory to inform their decision. This is a combination of art and science that makes it easier to know which colors will look good next to each other.

The color wheel

A color wheel is a visual way of showing the relationships between different colors. The basic color wheel is made up of 12 colors. There are three different categories of color in the color wheel: primary, secondary, and tertiary.

Primary colors are those that cannot be mixed from any other colors. They are red, yellow, and blue.

Secondary colors are mixed from two primary colors. There are three secondary colors in the color wheel—purple, orange, and green.

Tertiary colors are made when you mix a secondary color with a primary color. This creates six colors: red-orange, yellow-orange, yellow-green, blue-green, blue-violet, and red-violet.

The color wheel is your most important tool when it comes to making color decisions for your illustrations. By looking at where colors sit in relation to each other on the wheel, you can devise a color scheme for your painting that virtually guarantees the colors will work well together.

Colors that lie opposite each other on the wheel are called complementary colors. Each primary color's complementary is made by mixing together the other two primary colors—for instance, yellow's complementary color is made by mixing together red and blue to make purple. My personal favorite complementary

color combinations are orange and blue, and pink and light green. Using complementary colors can make for a fun and vibrant color palette, as just a tiny amount of a complementary can really make your painting "pop"—think of a single bright red poppy in a patch of green grass, for example, or oranges in a blue bowl. Beware of using complementary colors in similar amounts, however, as the result can be somewhat jarring.

When you choose predominantly colors that are near each other on the color wheel (for example, yellow, orange, and red, or blue, violet, and purple), you create what is known as a harmonious or analogous color scheme. Harmonious color schemes tend to create a calm, peaceful mood.

There are more complicated and technical-sounding color schemes, too. A split complementary scheme uses a secondary color and the two tertiary colors on either side of the opposite primary—for example, orange (secondary) and blue-purple and blue-green (tertiaries), while triadic harmony uses three colors that are evenly spaced around the wheel. But don't get bogged down in the detail: let your gut instinct be your guide, and if you feel something isn't quite working, take a look at your painting alongside a basic color wheel and see if you could "lift" it by adding a splash of a complementary color, or tone things down by making the colors more harmonious.

Color temperature

Every color has both warm and cold variations. For instance, lemon yellow is considered cold, whereas cadmium yellow is warm, and cobalt blue is cold, but cerulean blue is warm. When considering your palette, think about the feeling you want to evoke—if you want to create a warm scene, use only warm variations of color, and if you want to create a cold scene, use only cool colors.

Color mixing

You can create an infinite number of colors by simply mixing together different versions of primary colors. For instance, mixing Prussian blue and cadmium yellow will be an entirely different kind of green from ultramarine mixed with lemon yellow. You can also change the ratios to open up even more possibilities.

The easiest way to mix a brown is to mix a color with its complementary or mix all of the primary colors together with slightly different ratios. Play around with different color combinations to see what you can create. It's also a good idea to keep a note of what you've done, so that you can recreate similar colors in the future.

I recommend that you mix new colors on your palette rather than on your paper. You should also ensure that you mix enough for the area that you are painting—it's always better to have too much than not enough—as it's almost impossible to mix exactly the same color twice.

Shades, tints, and tones

These are technical terms that are bandied around a lot in art books, so it's good to know exactly what they mean. A shade is a color that is darkened by adding a second color. A tint is a color that is lightened. Tone (also known as value) simply describes the relative lightness or darkness of a color.

The simplest way to create a shade is to add black to a color to make it darker. Many artists advise against using black as it can muddy your colors, but it can work well in very small amounts. Another effective way to create darker shades is to add blue, brown, a darker shade of the same color, or a touch of the complementary color, depending on the shade you're after. Always experiment on your palette before applying it to your painting. By using this technique, you will create richer and less muddy colors than you would by simply using black.

The most usual way to make a tint in gouache is to add white. You can make a range of tones by just adding varying amounts of white. However, you don't always need to use white for tints: you could use yellow for the colors that already have yellow mixed into them such as green and orange. You could even use yellow to create tints of red if you want your lighter shades to be orange rather than pink.

Always experiment on your palette before committing your color mixes to paper.

Projects

Fruits & Vegetables

PALETTE USED

* Sap green
* Lemon yellow
* Zinc white
* Primary red
* Red orange
* Rose pink
* Ultramarine

Food is a great subject for bright, bold artworks, as there's a great diversity of color and textures to explore. Cans, boxes, and other packaged food are also good subjects, as they often have interesting labels and shapes. In general, food is an accessible subject and a great place to start when trying gouache for the first time—there's nearly always an apple lying around or a tomato in the fridge, and the shapes are relatively easy to construct. If you're on vacation, having local produce as your subject matter also allows you to explore a whole new food culture through art.

1 →

The fruits and vegetables I've chosen provide a bright mix of color and texture. You can lay out the food before sketching it or draw it from memory. Make a sketch of where you want everything to be. I chose to keep the rounder fruits and vegetables at the edges to give the composition a more circular feel, and added in small items such as peas and blueberries, to fill in the spaces.

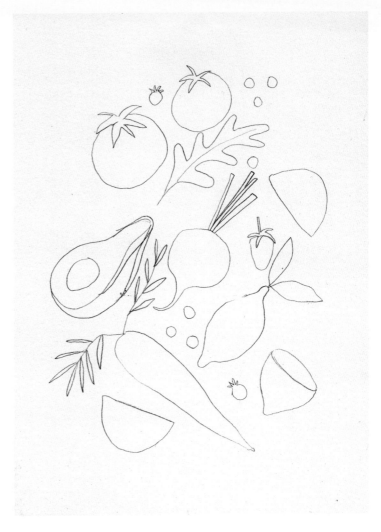

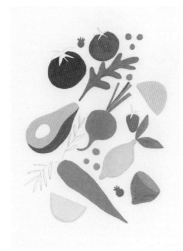

2 ↑

Block in the main colors, leaving the paint to dry before painting any areas that touch so that your lines are crisp and unblended. Apply the paint in different directions and work around the shape of each fruit and vegetable, as this will give you a bit of tone and texture.

To achieve the lime green (used for all of the green elements),

I mixed sap green and lemon yellow together. I always have zinc white on hand, ready to mix in small or large amounts to existing colors to create lighter shades (for example, the inner part of the avocado). For the tomatoes and strawberry, I used primary red and red orange to achieve a vibrant hue. For the carrot, I mixed red orange with lemon yellow. The onions were

a combination of rose pink and zinc white, giving a lovely pale pink hue. And finally, the purple for the beetroot is rose pink and ultramarine mixed together.

3 ↑

Next, paint the smaller details such as the leaves of the carrot, the tops to the tomatoes and strawberry, and the stones of any fruits. It's good practice to switch between brush sizes, using a small brush to fill in tight spaces and achieve nice clean edges, and larger brushes to create sweeping lines.

4 ↗→

Using your smallest brush size, add the detail and texture. For the onion's lines, I used the color I'd used for the beetroot with a dry brush and very little paint—allow your hand to wobble and apply inconsistent pressure to the brush to achieve a textured finish. Use zinc white to add segments to the lemon and lime, as well as darker tones to add details and shadows to some of the fruits and vegetables such as the veins on the leaf and shadows on the peas.

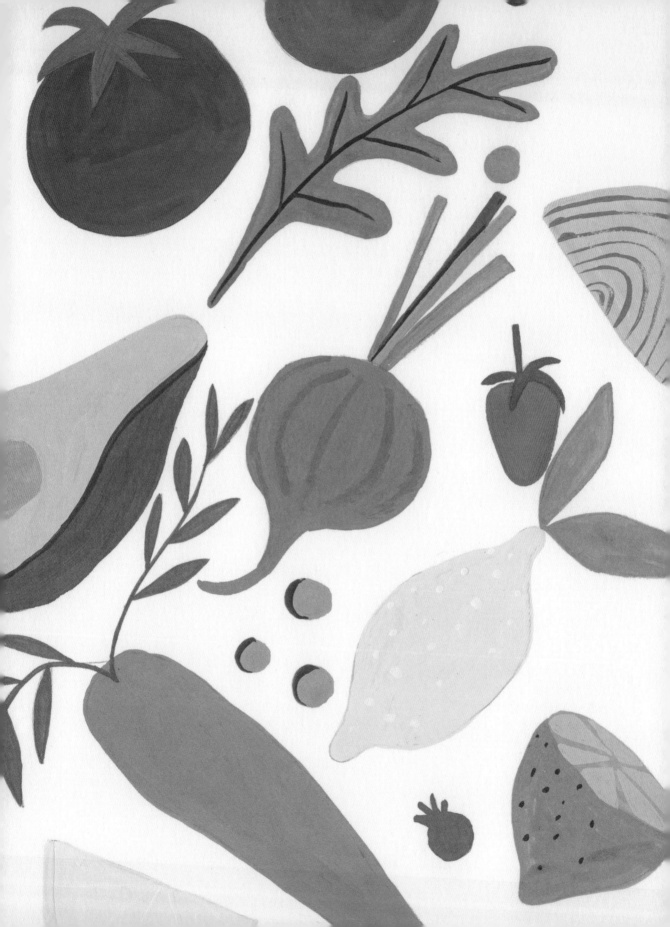

String Bag

* Lemon yellow
* Turquoise blue
* Indigo
* Linden green
* Sap green
* Primary red
* Yellow ocher
* Fir green
* Ivory black

To create a painting with depth and detail, you will need to layer different colors (see page 15). Layering is relatively straightforward with gouache, as a strong color can be painted over a lighter one without the underlying color showing through or affecting the final color, as it would in watercolor.

You will need to allow the base layer of paint to dry first to avoid the colors blending, but one of the advantages of gouache is that it dries quickly. For this project, I've chosen the ultimate layered subject—a string bag filled with shopping and a jumble of personal belongings.

1 ↑

Start by sketching the outline of the bag, making it fill the page so that you've got space to fit items inside it and still maintain a sense of scale. Then add the outlines of the objects inside the bag (note that some of them will stick out through the holes in the mesh). Choose your objects wisely— a jumble of sizes and shapes will help the objects slot together, rather than float around.

← 2

Think carefully about the color palette for the objects. I used cool tones—blues, yellows, greens, and grays—and added a banana for a pop of color. Decide what color each object will be and make a note of which objects overlap each other. In some cases, you will need to paint around overlapping objects (such as the keys that overlap the banana); in other cases, you may be able to paint straight over (such as the tube of hand cream over the notebook). It's easier to paint darker colors over lighter ones, so try and paint the lighter objects first.

3 →

Once the first layer of paint is dry, begin to add details such as the ends of the banana or the notebook label. I chose warm colors (reds and pinks) that contrast with the cool tones of the objects themselves. These colors also complement the string bag and help the objects to look distinct, rather than blend into each other.

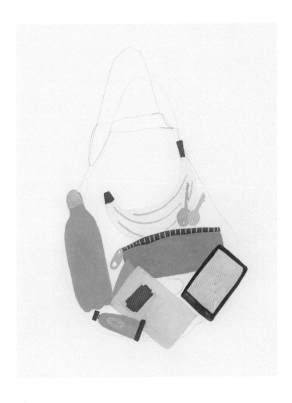

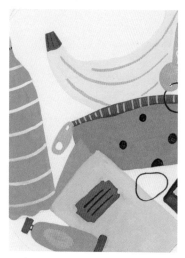

4 ↑

A block of color in gouache can achieve a bold, solid, finish, which is an ideal base for adding playful patterns. I added polka dots to the pencil case, but stripes, stars, and flowers all look great layered on top of a flat color.

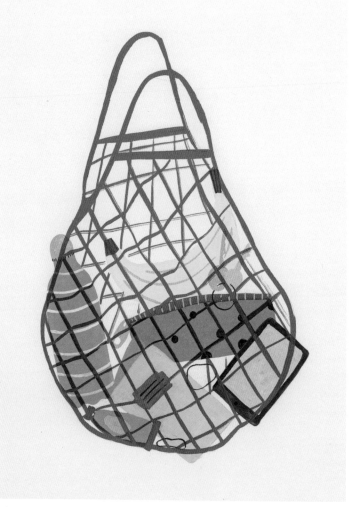

5 ↑

Now it's time to paint the bag over the objects. To differentiate between the front of the bag and the back, I painted the lines in two different directions—diagonal for the front of the bag and loosely horizontal for the back. I also painted the lines at the front solidly (the brush was loaded with paint), whereas those at the back are fainter (using a fairly dry brush). The lines at the back stop around the objects, allowing them to sit in front. Rather than

creating completely straight lines, which would look very mechanical, let your hand wobble slightly to give the bag a more realistic and relaxed feel.

TIP

Test colors and layers on a separate sheet of paper if you're not sure how they'll look when dry.

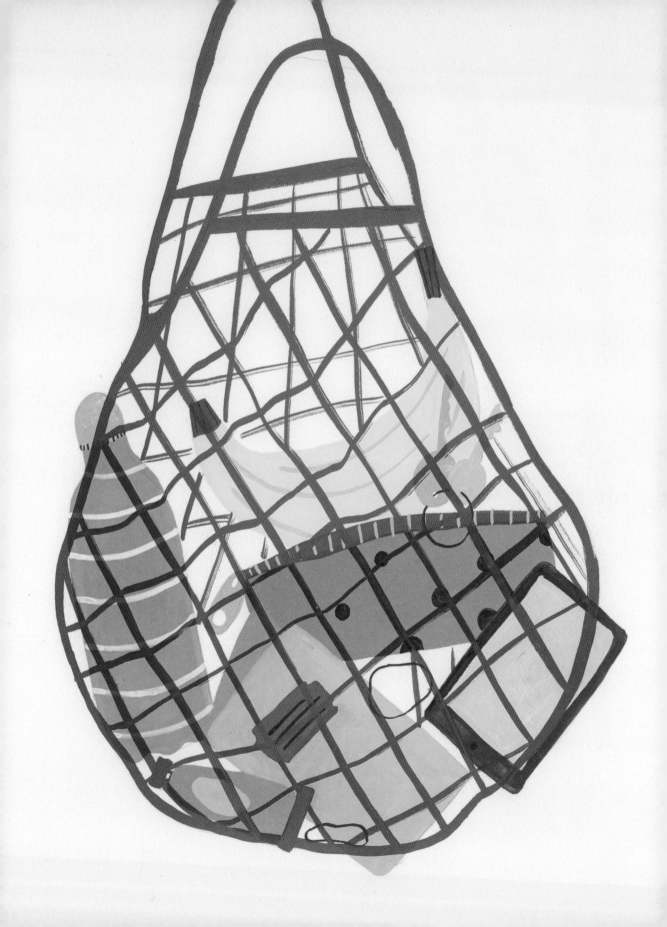

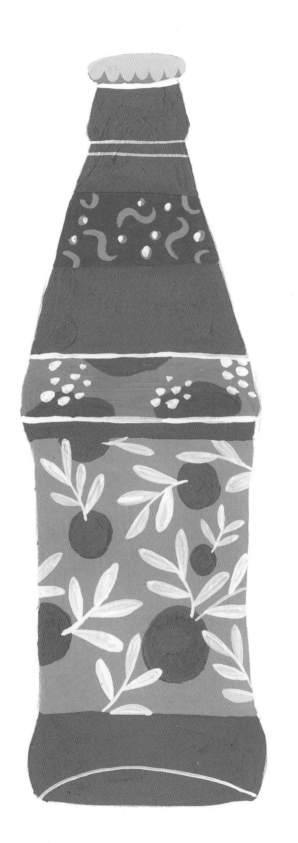
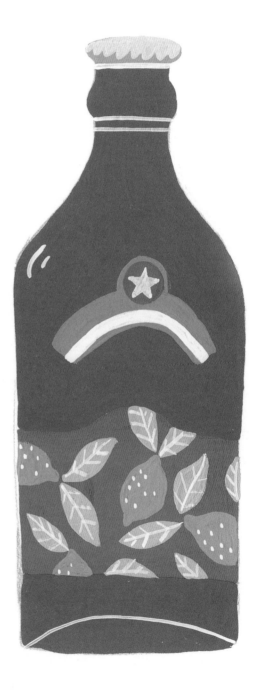

Patterned Bottles

PALETTE USED

* Primary red
* Ultramarine
* Zinc white
* Rose pink
* Flesh tint

Gouache is ideal for painting patterns, as its opaque and quick-drying nature makes it easy to layer different colors on top of each other for lines or marks. I chose to apply my patterns to two bottles, because the shape is easy to draw. I made the patterns up from my imagination.

← 1

Sketch the outlines of the bottles and some of the basic patterns. I chose a short and tall bottle to add interest to the composition. My patterns changed along the way, but drawing some initial outlines can be really helpful.

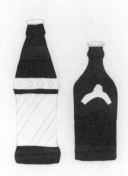

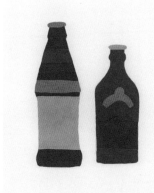

3 ↑

Next, apply your second color (in this case, ultramarine mixed with zinc white) to different sections of the bottles, using a fairly large brush. I left a blank section on the blue bottle, which I then filled in with rose pink mixed with flesh tint. This is because the pink isn't enough to cover the blue adequately, so it's best to leave a blank space to paint into. Make lighter tones of both colors and finish filling in the bottles.

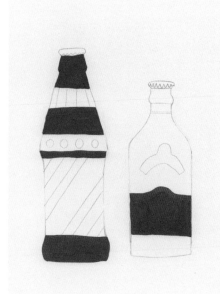

← 2

Start to block out the main colors. To create harmony, choose two colors that you want to use on both bottles. I painted the entire glass section on the left-hand bottle primary red, and then painted the label on the right-hand bottle the same color to link the bottles together visually.

4 →

Use zinc white straight from the tube—as it gives the most opaque and brightest color—to add highlights in the glass, and thin lines to show the definition of the bottles. Use a small brush—a size 1 is best for this—and don't overload it with paint; thin lines are best achieved with just a little bit of paint. Paint the details on the bottle caps in a very pale pink mixed from rose pink and zinc white. Let all the paint dry completely before adding any of the patterns.

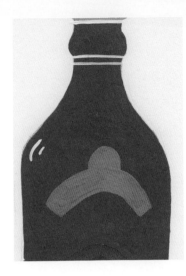

5 ↑

Paint patterns on the labels. You need colors that will stand out well, so pick tones that are substantially lighter or darker than your base colors and apply the paint thickly. This is where you can get really creative: I went for a lemon pattern, circles for oranges, and simple squiggles (which can be very effective and fun considering how easy they are).

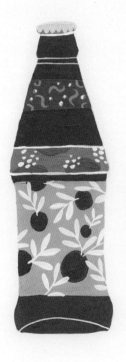

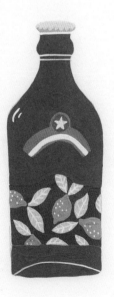

← 6

Add any final highlights and details in white. For the dots on the lemons and the veins on the lemon leaves, I used the tip of a very small brush. Using the same brush on its side, I painted the rainbow arch on the blue bottle label and the leaves on the oranges.

Cactus in a Pot

PALETTE USED

* Sap green
* Rose pink
* Zinc white
* Primary red
* Permanent green middle
* Prussian blue

For this project, the focus is on adding simple shadows to an object. The effects of light on an object can transform your painting, bringing it to life and making it look three-dimensional. If you're not confident about blending together a variety of tones, this is a straightforward way to create shadows. To demonstrate this clearly, I've used a very limited palette of green and pink. I've also placed my cactus in a position where the light is coming from the top right, casting a shadow on the left. Make sure you identify the source of your light, and that it is just coming from one source, as painting multiple shadows in different directions can lead to a muddled painting.

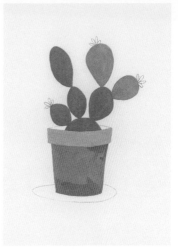

2 ↑

Load a medium-sized brush with sap green and apply this as the base color for the cactus. Start with the parts of the cactus that are farthest away from the light source, and reduce the amount of paint on the brush for the parts that are closer to the light. Do the same with the rose pink mixed with a touch of zinc white for the base of the pot. The rim of the pot juts out and is closer to the light, so this should be painted in a lighter tint; to do this, just add some more zinc white to the pink mix.

1 ↑

Choose a cactus with clear lines and sketch it, simplifying the shapes as much as possible. Don't worry if you need to adjust the outline a few times, as I have here, since the paint will cover the lines.

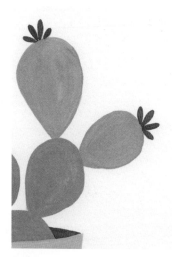
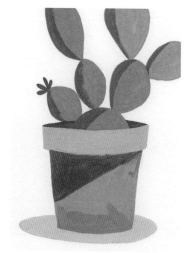
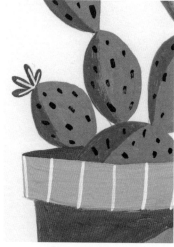

3 ↑

Make a decision about the areas of the cactus and pot that are well lit and the areas that are in shadow.

I've used rose pink straight from the tube for the inside of the pot and the flowers. For the shadow beneath the pot, I chose the lightest shade of pink (however, you could also choose to make this dark pink).

To create the flowers, add four thick lines that spread out from a point on top of a few of the cactus arms. Don't worry about painting thin loops, as it's easier to add a white line later.

4 ↑

To add shadow to the cactus, either use a darker green or mix a darker shade by adding some permanent green middle to your existing sap green. Apply it to the left side of the plant, being sensitive to the varying shapes. Use a fairly dry brush with just a small amount of paint, as this will help to add texture.

Add a small bit of zinc white and just a tiny touch of primary red to rose pink and use this to add a shadow to the pot—the angular shape that I've used can be as striking or as subtle as you like.

↑ 5

Paint the last details with a fine paintbrush. For the spines on the cactus, add a tiny bit of Prussian blue to your dark green mix and apply it with a fairly dry brush, pressing the side of the brush onto the paper to get a uniform shape for each spine. With zinc white, add lines around the rim of the flowerpot and up the centers of the flower petals, making sure you don't go all the way to the end.

> **TIP**
>
> Simplifying the shapes and lines of the shadows can give the artwork more impact.

Still Life

PALETTE USED

* Indigo
* Zinc white
* Ivory black
* Sap green
* Yellow ocher
* Prussian blue
* Red orange
* Flesh tint

A still life is a classic subject for a painting, but with the use of gouache and its fun, bright colors, you can give it a modern, contemporary twist. A still life traditionally consists of vases, flowers, fruit, fabric, and other familiar objects. You can make a selection that suits you, but it's important to include soft and hard objects, natural and man-made, to ensure that you have a good contrast in your painting. Experiment with different color palettes: you don't need to be realistic with your color choices—your painting can be bright and abstract or muted and serene. I like to use colors that don't necessarily match those of the real objects, as it allows personality and creativity to shine through.

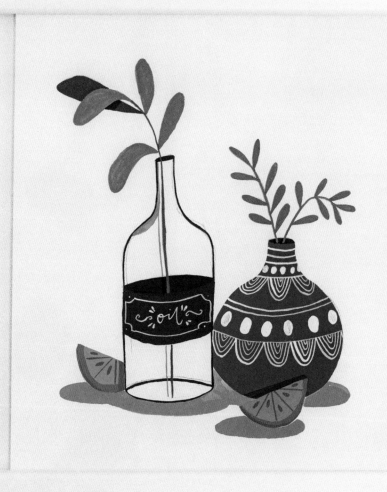

1 →

Begin by sketching your still life composition. Draw the main element and then position the smaller items around it, behind it, and in front of it. In my opinion, less is definitely more in a still life. If one of your objects is translucent, add in structural lines that you wouldn't normally see—in this case, the base of the bottle.

TIP

When layering paint, do not overload your brush. This allows you much more control over where and how you are applying the paint.

2 →

Block in the main shapes and outline anything that is glass or transparent. I used indigo mixed with a touch of zinc white for the vase, with a sliver of pure indigo mixed with a bit of ivory black for the inside of the vase. For the label and bottle outline, I used indigo straight from the tube.

When working with a transparent object, I use a dark tone for the outline and the base—here, the dark blue at the base of the bottle gives some depth. Adding a label and a flower stem that sits inside the bottle will also help to show that the bottle is transparent.

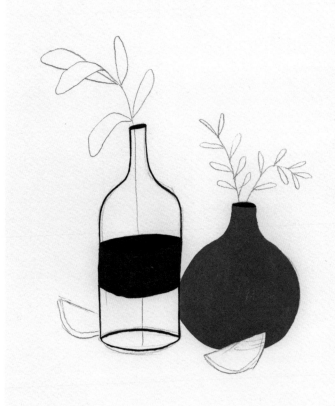

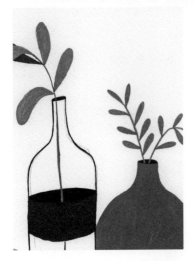

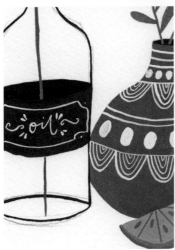

3 ↑

Use a small brush to paint the leaves and stems. I used varying shades of sap green, adding yellow ocher to the right branch and a small amount of Prussian blue to the rear leaf on the left. I painted the lemon segments with two tones, using red orange mixed with flesh tint for the inside, and pure red orange for the rind. I then used zinc white for the pattern on the vase and bottle label.

4 ↑

Finally, add in any shadows in a muted shade of grayish blue made by mixing indigo, zinc white, and a tiny bit of ivory black. Add shadows under the objects on the table to prevent the objects from "floating" in the space and to make them look more three-dimensional. Also add shadows where any objects appear behind others in the scene. For instance, I've added a slim shadow on the inside of the bottle to help give it a sense of depth.

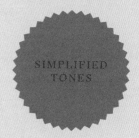
In the Wardrobe

PALETTE USED

* Ultramarine
* Zinc white
* Yellow ocher
* Burnt umber
* Ivory black

Being able to assess tones (how light or dark a particular color is) is key to painting three-dimensional paintings. This exercise uses a limited palette to give you the opportunity to practice making different tones of the same color. Choose two colors that are opposite each other on the color wheel—for example, red and green, yellow and purple, or (as here) orange and blue. These are known as "complementary colors," and using a pair of these in a painting can really make it zing.

The easiest way to create different tones with gouache is to add varying amounts of white to your chosen color, and then use the pure color from the tube for your darkest shade. For more on color mixing, see page 29.

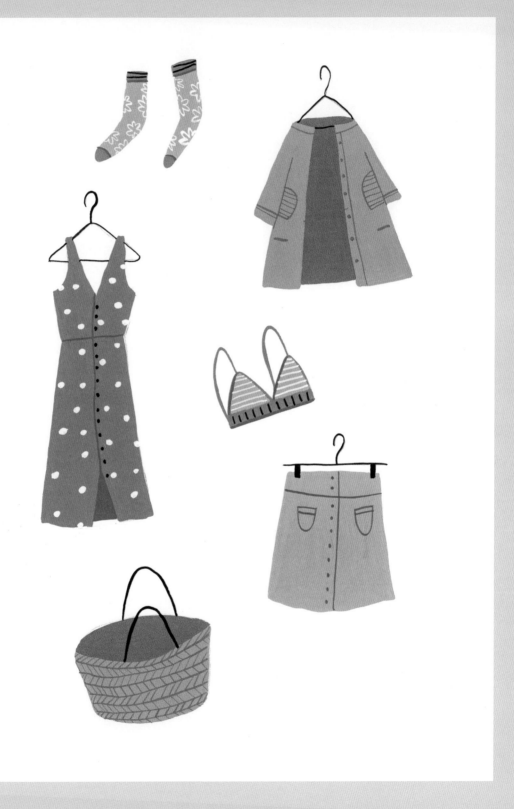

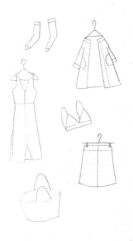

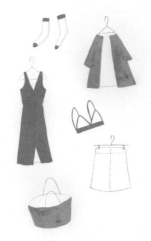

← 2

Select two core colors and choose a shade of each to act as your mid tones. Use these colors to block out the main elements and the largest areas of color. They can also be used to create outlines for the smaller items such as the bra and socks.

1 ↑

To create a composition, select items of clothing that you particularly love or that mean something to you. Or to make it more interesting, you could choose a theme such as "rainy-day clothes." Lightly sketch them on your canvas, aiming for a good range of shapes, sizes, and angles.

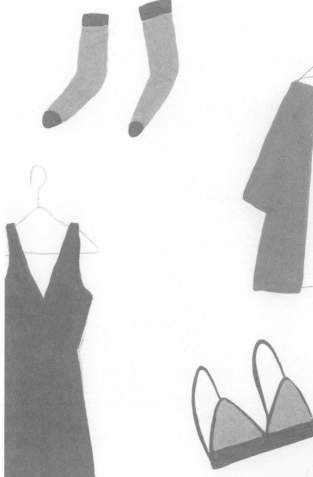

3 →

From here, you can create your lighter and darker tones. For my shades of blue, I began with ultramarine mixed with zinc white, so that I could add some more white for my lighter tones and use pure ultramarine for my darker shade. For the yellow, I used pure yellow ocher for my mid tone, so I added some burnt umber for my darker tone. Use a small brush to fill in the lighter tones on the more delicate pieces.

4 ↑

Paint areas that would be in shadow such as the inside of the jacket, dress, and bag in a darker tone.

Use the smallest brush you have to achieve the thin lines for the details on the clothes such as seams, buttons and pockets. To create the basket texture, paint horizontal lines across it (a loose grip on the paintbrush and a bit of a wobble will make it feel more organic and realistic), then add diagonal lines between the horizontal ones.

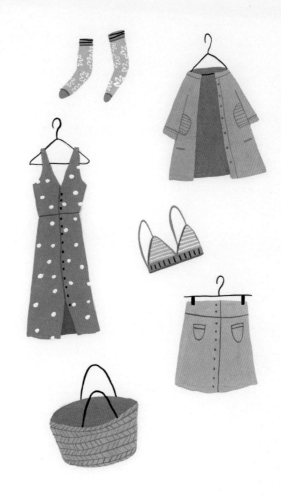

5 ↑

Use ivory black and zinc white paint to add final details such as hangers and bag handles. You can also apply patterns to the fabrics—they could be polka dots, stars, flowers, or stripes. Avoid adding pattern to all of the items though, as your painting will end up looking overworked.

> **TIP**
>
> Starting from a mid tone makes it easier to judge how much darker or lighter the rest of the painting needs to be.

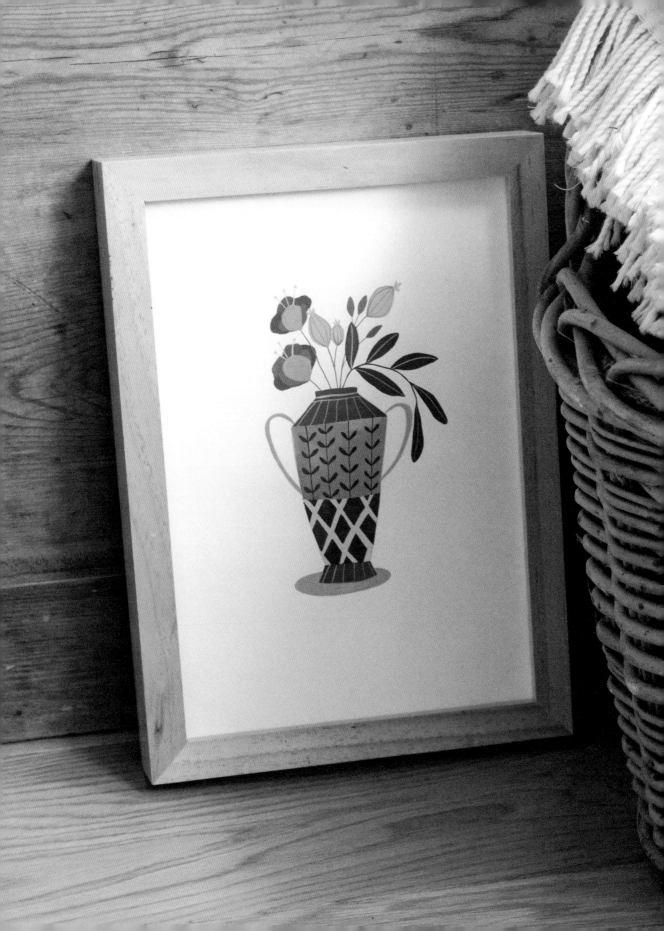

Vase of Flowers

PALETTE USED

* Fir green
* Rose pink
* Zinc white
* Turquoise blue
* Permanent yellow deep

You can create a dynamic painting with plenty of interest using a limited palette of just three to five colors. A great way to vary your limited palette is to create different tones of the same color by adding white. This project involves man-made objects, elements from nature, and lots of additional pattern and detail. By layering paint, creating different tones, and making smart choices about which elements to paint in the same color, the painting can feel as exciting as a rainbow.

2 →

Block in the largest parts, avoiding any fine pattern or detail—it will be easier to paint that separately. So long as your base color is lighter than the color of the detail (in this case, the leaf pattern), you can paint over it—you should still be able to see your pencil guidelines. I used fir green for the top and base, and rose pink mixed with a small amount of zinc white for the center portion and handles.

You can also add in the shadow at the base of the vase at this step. I've mixed a turquoise blue with a small amount of white for this, but it would also work if you mixed the fir green with some zinc white.

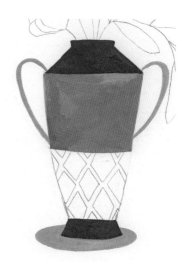

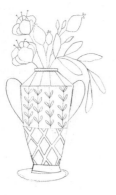

1 ↑

Pick a vase that has an interesting shape and a pattern or some detail on it—or invent one from your imagination. I've added a diamond trellis design and leaf patterns to mine. Inside the vase, I've placed flowers, buds, and leafy greens to give a mix of structures and shapes, with some looser elements (the foliage) drooping over the rim. Sketch out your design, making sure to include all of the detail in the initial drawing.

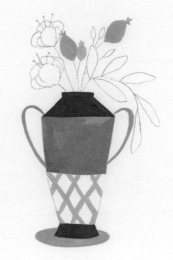

← 3

Use your chosen colors for both the plants and the vase. Here, I used permanent yellow deep for both the organic seed heads and the geometric lines of the trellis pattern.

TIP

A mix of geometric and organic pattern types works well for contrast.

← 4

I also applied the fir green from step 2 to the base of the vase behind the trellis pattern and the foliage. This ties the whole image together and creates a mirroring effect between the solid vase and its contents.

5 →

Continue to use your colors carefully, switching from vase to contents. To paint the flowers, start with the darkest shade and apply this to the rear, then move on to the petals in front, each time adding a little more zinc white, and allowing each layer to dry between applications. Paint the smaller leaves a lighter shade of green than the large leaves.

Adding a flash of a completely different color can really lift the whole painting. I've created an orange color by mixing rose pink and permanent yellow deep together and added fine lines to the seed heads. This helps to make the seed heads stand out beside the blue-green foliage. Using different tones of the same color helps to give the painting a sense of depth.

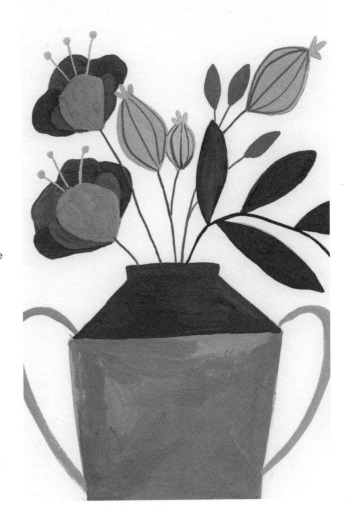

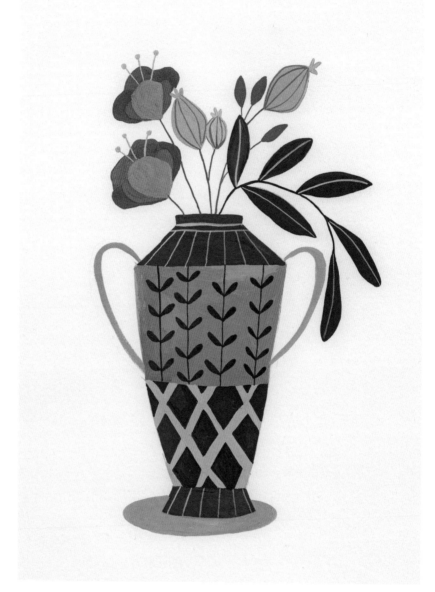

6 →

Make sure your painting has fully dried before adding the white lines and dark leaf pattern to the vase. When applying details in white, make sure you use a very clean brush to avoid murky lines.

VASE OF FLOWERS 61

Bunch of Blooms

PALETTE USED

* Flesh tint
* Zinc white
* Sap green
* Rose pink
* Permanent green middle
* Prussian blue

Artists tend to feel nervous about painting hands, so it's a good idea to start with a composition like this, where the focus is on the bouquet, and the arm and hand are almost incidental. Including the hand gives a wonderful sense of movement and context. This is the ideal composition for a thank-you card!

TIP

Use color theory (see page 25) to choose your colors. Complementary colors will make your painting pop.

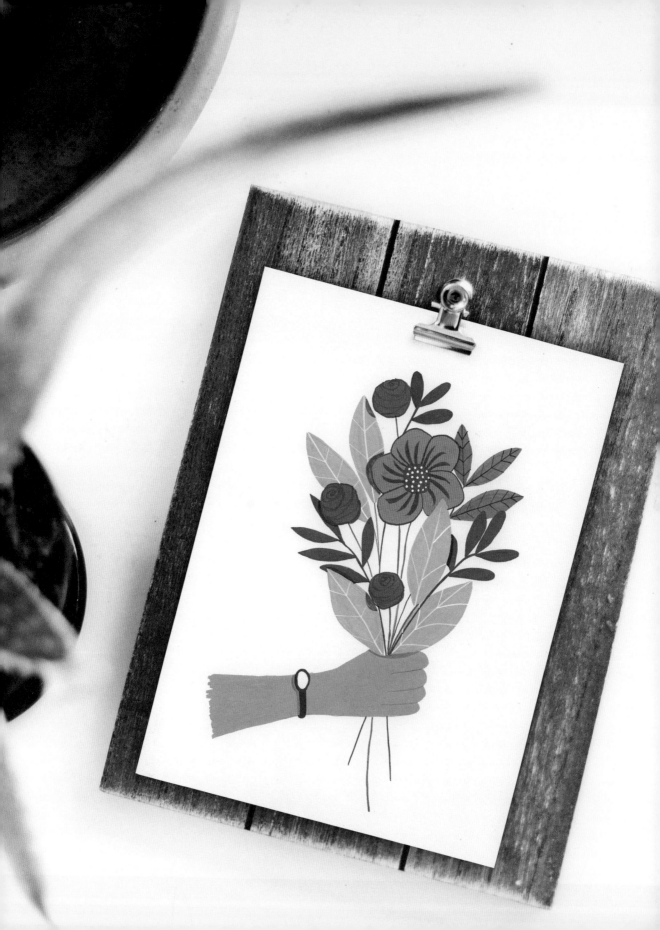

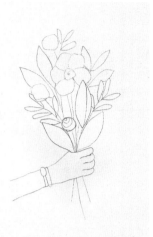

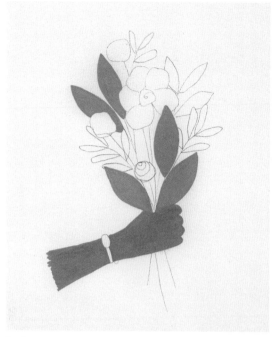

1 ↑

Sketch out your composition, starting with the hand—this makes it easier to get the scale of the flowers right in relation to it. Concentrate on the overall shape rather than trying to put in the individual fingers at this stage, otherwise you may find that you make the fingers too big. You can practice drawing the hand on a spare piece of paper, using your own hand as a reference. Once you're happy with your drawing, take a copy or photograph of it to refer to later in the project.

For the bouquet, select a good mix of foliage and flowers that will allow you to add a variety of colors. Think carefully about scale and shape; you want a range of large and small leaves, open flowers and tighter blooms, and buds.

2 ↑

Now block in the hand and arm, working around the shape of the wristwatch (detail and shading can be added later)—I used flesh tint mixed with a little zinc white for this (see page 71 for skin tones). Then paint the larger leaves with sap green mixed with some zinc white. Use a medium-sized brush for both of these so that you can cover the area quickly before the paint dries, and load a good amount of paint onto the brush to get a smooth, even finish.

← 3

For the flowers and buds, I chose two shades of pink to contrast with the green. The darker pink is rose pink used straight from the tube, and for the lighter shade, I simply added a little zinc white. Use a medium-sized brush for this as well, as the shapes aren't too delicate.

← 4

Use a small brush for the stems and smaller leaves, as this will make it easier to achieve thinner lines and to keep the shapes of the leaves precise. Use a mix of greens to create some variation in the foliage, using permanent green middle for the mid-toned leaves and creating a darker green by adding a tiny bit of Prussian blue.

5 ↑

Now for the details. Mix a darker shade of pink by adding a touch of Prussian blue to the rose pink. Place the tip of a small brush in the middle of each rose and paint a tight spiral, working your way outward until you reach the edge. Make your lines slightly wobbly to give your flowers a more organic look. For the leaf veins, choose either a darker green or a white and add some tiny white dots to the large flower's center. Finally, paint any jewelry, rings, or watches on the arm holding the bouquet.

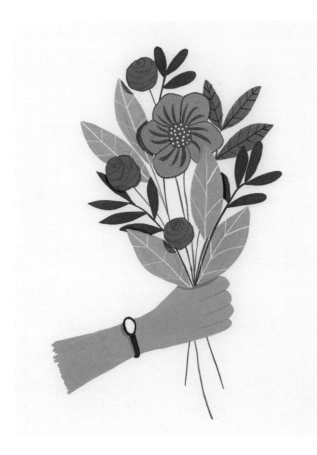

← 6

The final stage is to add shadow to give depth. Using a slightly darker shade than you used in step 1, paint thick shadow lines alongside the watch, on the hand just under the bottom leaves, and between the fingers. You may need to refer to your copied sketch of the hand to get the placement of the fingers just right. You can also add some shadow onto the bouquet—I have incorporated shadows where leaves and flowers are overlapping one another.

A Simple Portrait

PALETTE USED

* Flesh tint
* Yellow ocher
* Primary red
* Permanent green middle
* Rose pink
* Zinc white
* Red orange
* Primary blue

Portraits are a fantastic way to explore different faces, people, and expressions, and create cute pictures for friends and family. For a simple portrait like this, you can work from real life, a photo, or from your imagination. If you're new to drawing people, then working from a photo is a good way to get started, as you can sketch and re-sketch the face shape and features until you have them just right. Because gouache is so easy to layer, you can easily add accessories such as glasses and earrings at the end.

1 →

If you're just starting out on portraits, choose a subject with a simple face shape. Draw outlines of your subject's features and accessories. Before you begin painting, either sketch a copy of your drawing or take a photo of it. You'll be painting over the pencil-drawn features, so it's a good idea to have a reference to help you paint the detail back in.

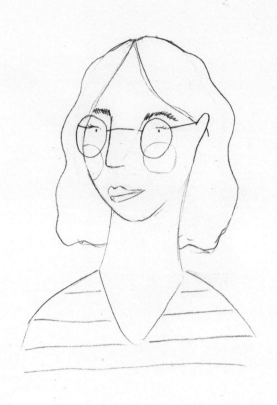

← 2

For the skin color, I mixed flesh tint and yellow ocher. Use a fairly large brush to apply enough paint to cover the area. For the hair color, I mixed primary red, permanent green middle, and yellow ocher to get a natural dark brown. I used the same brush as before to apply a thick layer to cover the area quickly. I've mixed rose pink with a small amount of zinc white for the base color of the top.

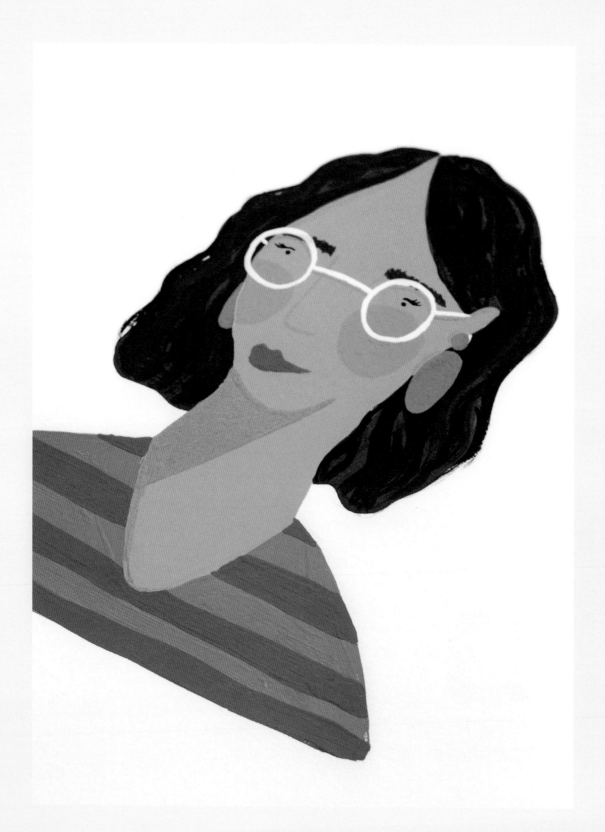

3 ↑

Add the details to the clothing—I chose stripes in red orange. For the light brown detail on the hair, I added a small amount of zinc white to the brown mix. Use a slightly dry brush to apply waves to the hair, which will give the stroke a coarse texture.

←4

The next layer consists of any detail you'd like to add to the skin—in this case, rosy cheeks—and also any shadows. To achieve the shadow color here, I added a tiny bit of the brown from step 3 to the original skin color. To define the chin, paint a line to mark the shape of the chin, and then paint the shadow it would cast beneath it—I find that a bold, angular shape works best. You can also add some shadows around the hairline and ears to give the face more definition.

For the cheeks, I created a pinker shade of the skin tone by adding a tiny bit of rose pink. Don't forget to refer back to the sketch or photo you took at the beginning, because it might be tricky to remember exactly where the rosy cheeks should be.

TIP

Don't try to paint every strand of hair—just make enough marks to give an impression of how the hair flows.

←5

For the nose, use the same shade as the shadows. Using a small brush, paint a delicate, thin line. When painting the eyebrows, use the same shade as the hair and avoid loading the brush with too much paint, as it's easy to lose control of the application. Paint lots of little lines in upward strokes to create a natural texture. Lastly, for the eyes, use the tip of your smallest brush to add small dots using black or a very dark brown (here I used the hair color).

6 ↑

The mouth is often the part that people find the hardest to paint, but I've found that this shape works well and is easy to adapt. Outline the shape of the lips before you fill them in—and start small. It's easier to change the shape if you have room to make the lips bigger. I used a slightly lighter shade for the top lip than for the bottom lip, which allows you to see the definition between the two.

If the hair is dark, it's a good idea to choose a lighter shade for the glasses, as it helps them to stand out from the rest of the face; here, I used white. With earrings, you can be as wacky as you like— I opted for a primary blue so that it stands out against all the other warmer colors.

7 ↓

To finish, use a thin brush and the same shadow color as before to put in any shadows cast by the accessories. I added a thin shadow underneath the glasses and alongside the earring.

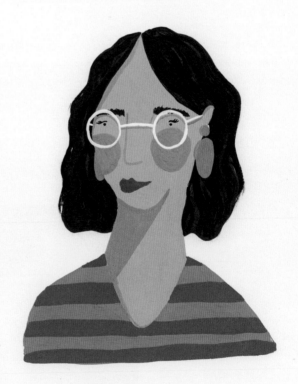

TOP TIPS: SKIN & HAIR

Faces are one of the things that people really shy away from, fearing that they won't achieve the likeness of the person they're painting. With gouache, you can focus more on getting the color right and add little details that make someone individual, rather than worrying about getting an exact copy of them. You can capture someone's character with just a little expression, their hair color and style, and some accessories.

When painting a face, keep the brush fairly flat and even, as it's unlikely you'll want much texture—you want a smooth finish.

The four different skin tones on page 73 have all been achieved with a very limited color palette. I've used a varying mix of flesh tint, zinc white, yellow ocher, sap green, and red orange. However, most skin colors can be made by just using the three primary colors and white. For example, the color brown can be achieved by just mixing all three primary colors together with some zinc white, and to create a pale peach color, you can mix primary red, primary yellow, and zinc white together. By adjusting the ratios of these color combinations, you can create a huge range of skin tones, as well as different shades for shadows.

For the pink tone of the man with the beard, mix flesh tint and zinc white or mix primary yellow, primary red, and zinc white together, adding a tiny bit of extra primary red to create a pinkish tone.

For the peach tone of the woman in the green polka dots, use flesh tint straight from the tube or primary yellow mixed with primary red and zinc white, adjusting the ratios slightly from the bearded man to use less primary red.

For the woman in the striped pink top, mix up red orange and sap green or the three primary colors to make a brown, then add a small amount of yellow ocher and zinc white until you have the shade you are looking for.

And finally, for the woman wearing glasses, add a small amount of yellow ocher to zinc white and a touch of flesh tint (or primary yellow and primary red).

The best way to achieve good-textured hair is to apply a base color—this could be a thick application, as with the woman in the pink stripes, or a diluted paint mix to achieve a stain, as with the woman in the green polka dots. Once you have a base, you can add highlights, lowlights, movement, and even curls on top by creating different shades of the base color. Play around with strokes and use a small brush for fine details. The drybrush technique works well for these details.

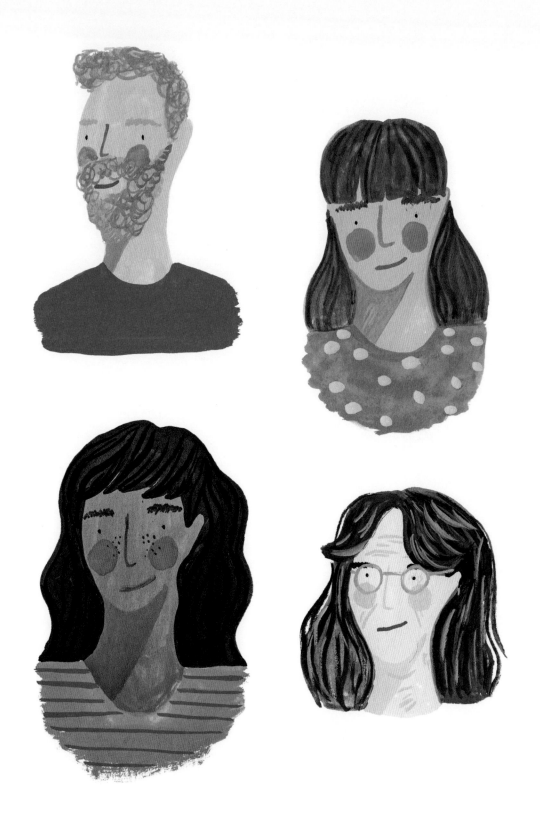

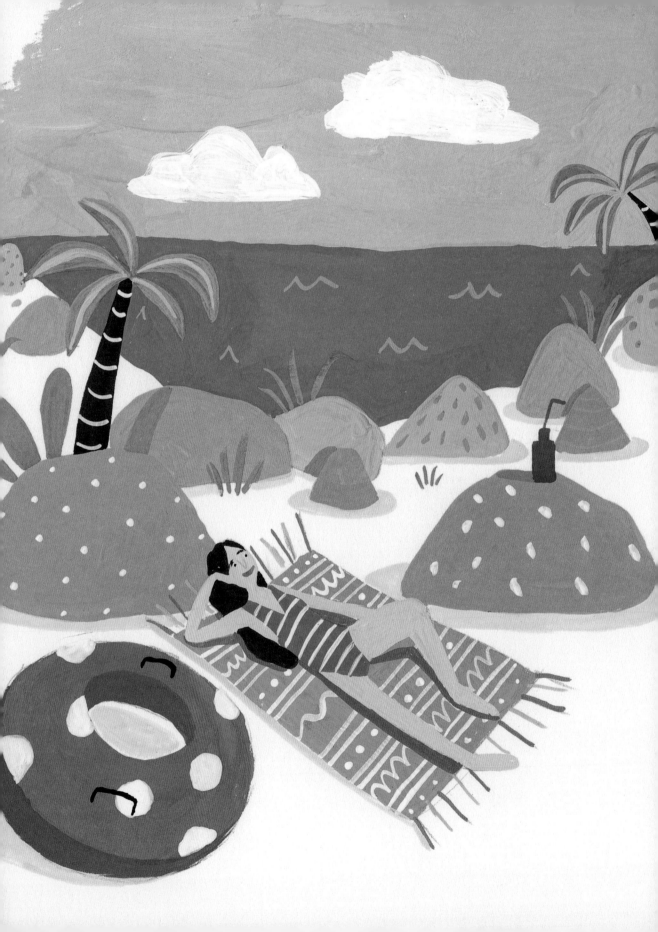

Beach Scene

PALETTE USED

* Turquoise blue
* Zinc white
* Indigo
* Yellow ocher
* Sap green
* Primary red
* Rose pink
* Red orange
* Flesh tint

Painting from your imagination is a real challenge. With nothing to refer to, it can be hard to visualize where to put your brush next and how to accurately depict what you can see in your mind. But it's a great skill to practice, as it enables you to add imagined elements to an observed scene and to work at any time in any place.

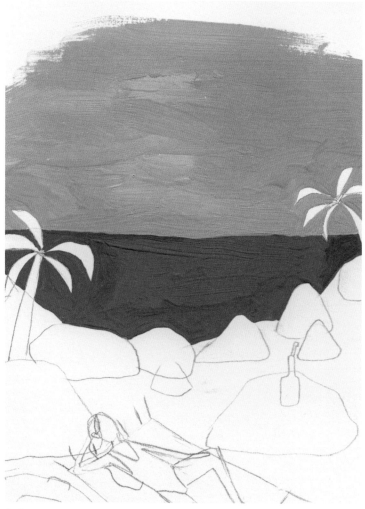

1 ↑

When you're creating a composition from scratch, it's best to start with the primary focus—in this case, the woman sunbathing. Once I had established her position and drawn her in detail, I added foreground elements such as the inflatable ring, then added background details, making the objects gradually decrease in size. Positioning the largest objects first makes it easier to determine the scale of all the other elements. Leave room for further additions and creative flourishes.

2 ↑

Once you have sketched out your scene, you can begin painting. Start with the largest areas in your image (in this case, the sea and the sky), as having the main color in place will help you make good color decisions and define the rest of your palette. I used turquoise blue mixed with a little bit of zinc white for the sky and the same color with some indigo mixed in for the sea, carefully painting around the palm tree leaves.

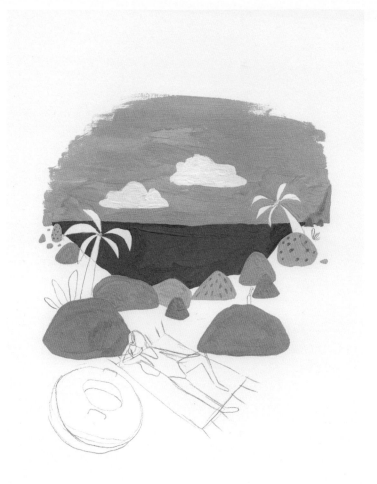

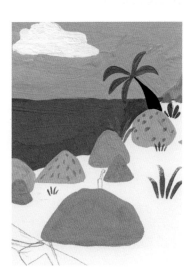

← 3

It's a good idea to complete all of the similar elements in phases; for example, I painted all of the rocks second (in yellow ocher) followed by the leaves, grasses, and tree trunks (using sap green mixed with a little yellow ocher for the palm leaves, and primary red, sap green, and yellow ocher mixed together to achieve the brown color for the trunks). This allows you to change the shades of the colors gradually and build the composition in parts. In my painting, the rocks get darker toward the foreground, and I've used the same dark shade to add detail to the rocks in the background.

TIP

Working from your imagination allows you to add any creative touches you fancy, from polka-dot rocks to a jaunty green straw in the bottle.

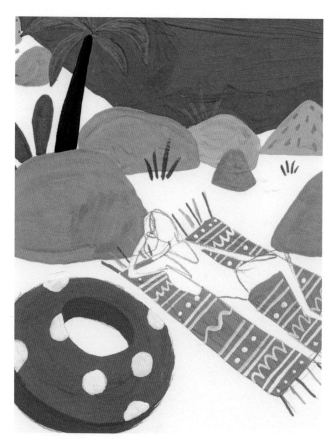

← 4

As the artwork comes together, you'll find you have space to play around with the details. In my original sketch, I had a glass on the rock, but as I fleshed out the composition, I could see that it would not stand out, so I turned it into a bottle instead. Patterns are a great way to liven up a piece—I added polka dots to the rubber ring and stripes to the towel, painting the pink and red base colors first and allowing them to dry before adding the white patterns. I used rose pink mixed with a little zinc white for the beach towel, and red orange mixed into this pinky color for the rubber ring.

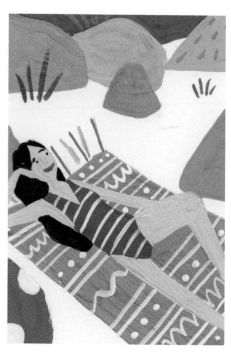

5 →

Now, paint any small, tight areas such as the sunbather's body and swimsuit. Use a small brush and avoid loading your brush with too much paint—this will give you more control. For the sunbather's body I used flesh tint paint mixed with a small amount of white. I prefer not to introduce too many different colors at this stage to avoid the painting becoming too busy. I used the same brown from the tree trunk for the sunbather's hair, and the swimsuit is the same color as the sea. Re-using the same colors also helps to tie the image together and make it look more uniform.

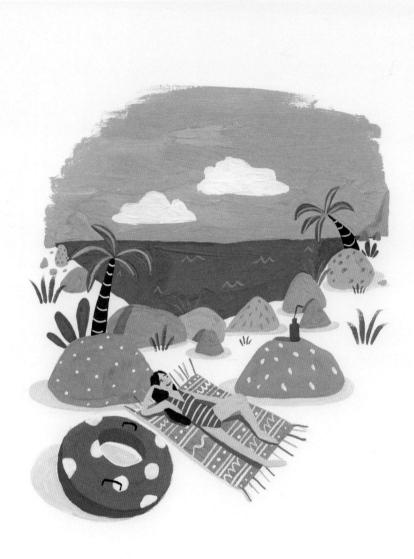

6 ↑

Finally, put in any cast shadows to anchor the work and stop it looking as if the elements are floating in space. Here, I imagined that the light is coming from the right, so I placed all the shadows to the left of the objects that cast them. I used yellow ocher mixed with a small amount of zinc white to achieve the shadows, as well as pure rose pink for underneath the sunbather.

TOP TIPS: PAINTING SKIES

A sky can dominate a landscape painting, so it's worth practicing different types of clouds, colors, and techniques.

For a solid-looking sky (such as the blue sky opposite), mix a color without adding any water to the paint, then apply it in thick, heavy brushstrokes. This is ideal if you're painting a bright sky for a summer scene. Because the paint has been applied thickly, wait until the layer is completely dry before adding any clouds on top.

White clouds can be applied to a blue sky if you keep the paint thick, so it remains opaque—it doesn't matter if the blue shows through slightly in areas as it will only make your clouds look more realistic.

For the rough edges, use the drybrush technique—keep your paint mix and your brush both fairly dry so that the texture of the bristles translates to the painting.

For a soft, evening sky that looks like a wash, try using the staining technique. Apply a lot of water to some blue paint with a tiny bit of black and some white added, and then use a large brush to apply in broad, sweeping strokes. Go over some parts twice to give an uneven finish that will look a lot like watercolor.

For a sense of depth in the clouds, paint the clouds in the foreground the darkest shade of a color, and progressively use a lighter shade as you work your way back. A warm pink (such as the clouds opposite) will work perfectly to capture a sky at sunset. Adding white highlights will do a lot to lift the painting.

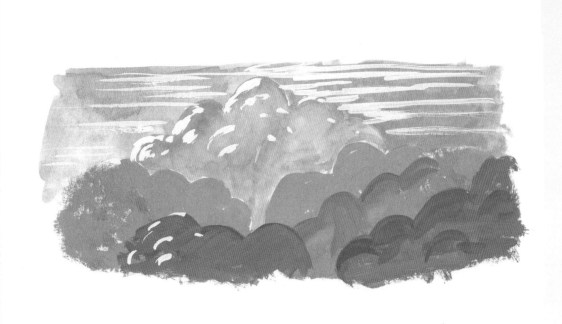

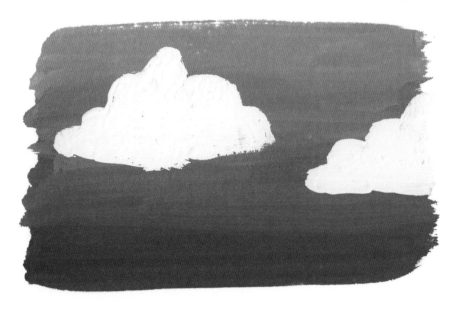

Floating in Space

PALETTE USED

* Indigo
* Ivory black
* Zinc white
* Ultramarine
* Flesh tint
* Yellow ocher

When you're working on top of a dark background color, add only a minimal amount of water to your paint—this will help the paint remain thick and strong enough to cover the dark background for clean lines. For areas that you know are going to have a much lighter color on them, it's best to leave these unpainted to avoid mixing with the color below.

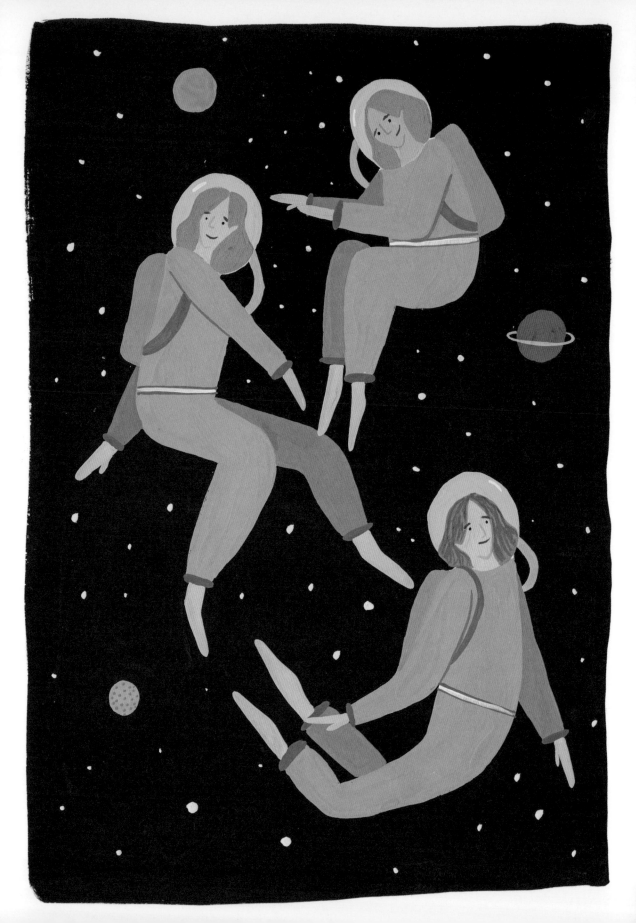

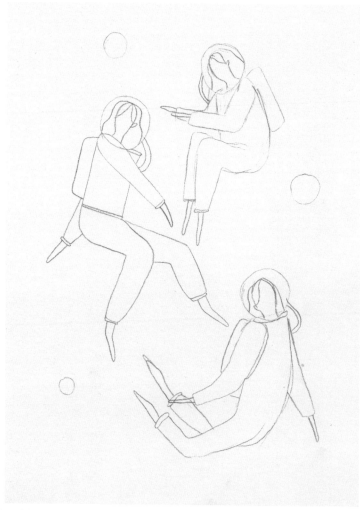

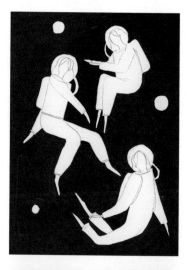

1 ↑

Sketch out your space scene. I haven't added any detail to the background apart from the odd planet. The background is a dense dark hue, so it's best to layer the small details (such as stars and planet rings) on top at the end, and leave any larger light areas unpainted.

For the deep night sky, I've used indigo mixed with a small amount of ivory black—a really dark purple would work well too. Paint the bulk of the background with a medium-sized brush. Use a smaller brush to outline the characters you've sketched without going over the lines.

2 ↑

Two shades of the same color is a great way to add depth to a simple illustration. I mixed different quantities of zinc white with indigo for the astronauts' suits. Use a darker shade for arms and legs that appear to sit behind the limbs in the foreground to make them look less flat. Using a very thin brush, also use this darker shade to paint lines for the arm and leg creases.

← ↓ 3

Using contrasting colors to paint the planets, helmet, and other larger areas of the astronauts' clothing will give them maximum contrast against the night sky. I've used oranges and yellows to contrast with the blues and purples of the suits and planets.

I used a small brush to paint in cuffs and belts in ultramarine, the gloves and boots in ultramarine mixed with zinc white, and the astronauts' hair and faces with different shades of flesh tint and yellow ocher. Give your astronauts facial features, using your smallest brush.

4

The last step is the most fun: adding detail to the night sky. For the stars, use a small brush with a generous amount of zinc white paint on it (but not too much that you run the risk of paint falling onto your painting), and dot some spots all over the background— don't worry about these being too even. You can also add some patterns onto the planets—spots and stripes work really well here. Add a touch of white to the helmets to give them a 3-D feel, and pick out any details—such as the belts—in white too.

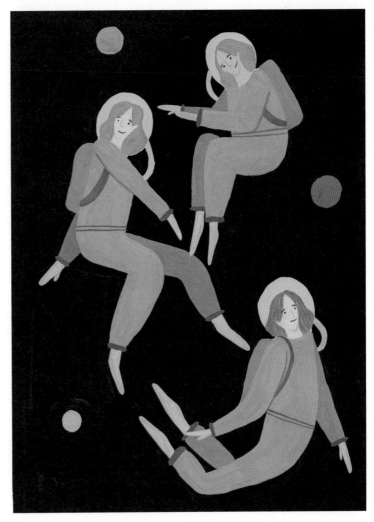

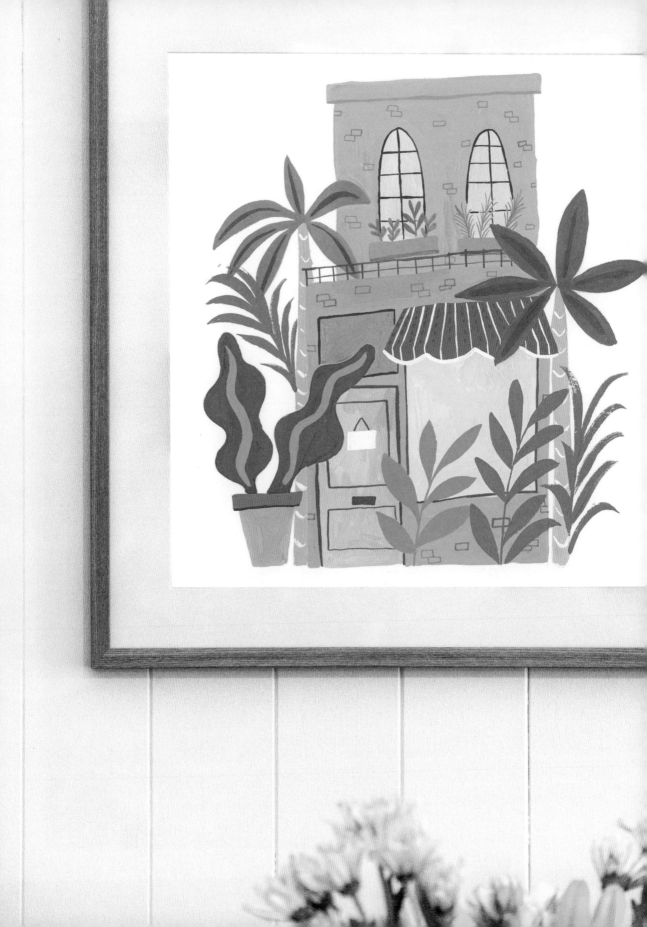

A Picture of Home

PALETTE USED

* Sap green
* Zinc white
* Fir green
* Ultramarine
* Rose pink
* Yellow ocher

You don't need to achieve architectural accuracy to paint buildings—a gestural, characterful painting can bring a store or home to life just as well. This is especially true if you're painting and drawing while on vacation, as you may not have the time to stop and capture every detail. A quick sketch and painting can depict the colors and vibe of a place—this store was one I photographed in France.

1 →

First choose your building—the more character it has, the more fun you'll have painting it—and then do a rough sketch of it. If painting a whole row of stores or houses is too daunting, simply focus on one building and isolate it from the surrounding ones. I've framed my store with trees and foliage that I spotted elsewhere, bringing the two together in an imagined scene.

2 →

Paint the main color of the building, avoiding any windows, doors, and plants. You do not need to use the same color of your reference building; I've gone for a tropical vibe and used sap green mixed with zinc white for the lighter shades, adding fir green to create a darker shade. Use a medium-sized brush to apply the paint and leave some texture in your brushstrokes (rather than a flat, even finish) to give the sense of rough brick or plaster. Paint the bottom section slightly darker than the top, as this helps to give the building definition and depth.

3 ↑

I've selected ultramarine for the windows and door, adding zinc white to make the blue very pale. To achieve the washed finish, add water to the mix and keep the brush loose and fluid as you paint.

4 ↑

To add a pop of color, I've chosen rose pink for the canopy and the plant pot, which complements the pale green. For the plants, mix a dark shade of green to make sure that they stand out against the building. For the plant on the left, I used fir green straight from the tube, and for the two palm trees I used sap green mixed with varying amounts of fir green to give the different shades. You can use a slightly smaller brush here to help you get the pointy ends of the palm trees.

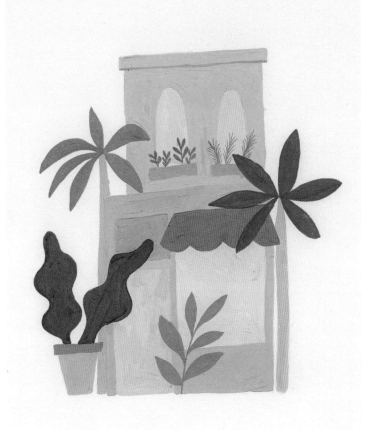

↑ 5

As the painting develops, you can add other elements. Perhaps a lamppost in front, a bicycle leaning against the wall, or some neighborhood cats lazing by the door. I've added plant boxes on the window sills using the same greens from the previous step. You could also add in the palm tree trunks at this stage: I mixed yellow ocher and zinc white to get this nice light brown color.

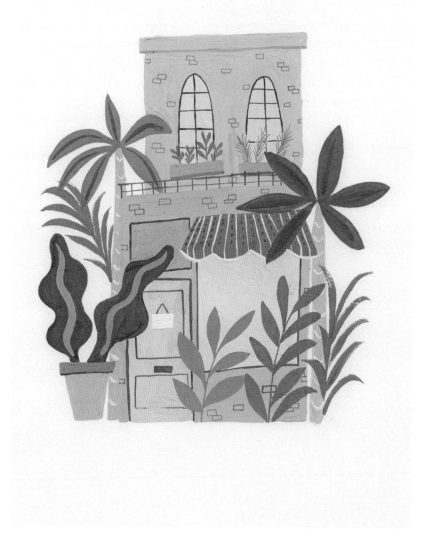

6 ↑

Finish by adding details and imaginative flourishes such as door frames, bricks, window frames, and a balcony railing. Again, gestural touches go a long way—you don't need to paint every brick. Use the smallest brush you have and avoid loading up the brush with too much paint; the last thing you want is a big blob on your lovely painting!

OTHER IDEAS

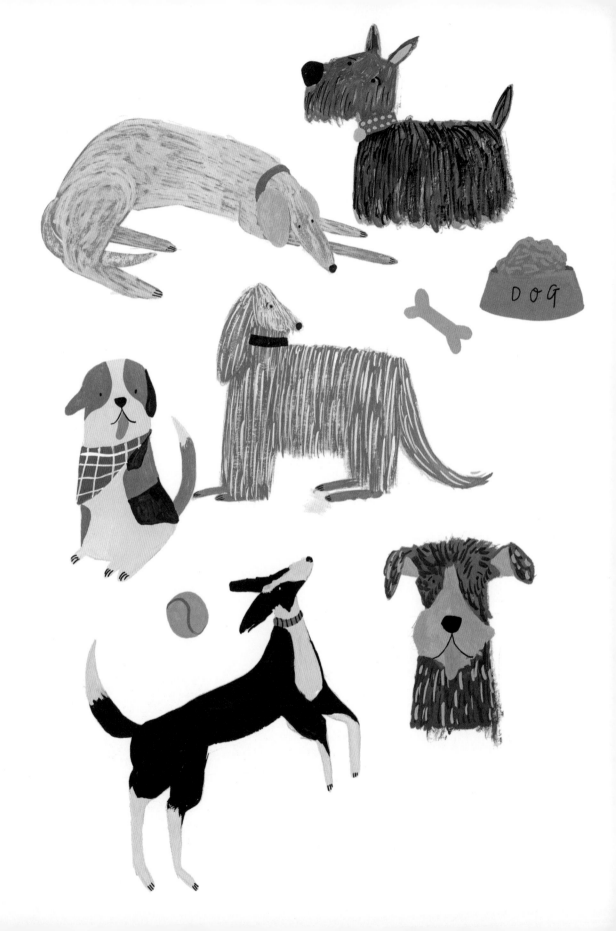

Motley Dogs

For this project, I've painted a variety of dogs, varying their poses for a cute and motley crew. You can have some standing, laying, and jumping. Every dog is different so look at plenty of reference photos or take some sketches in the park to get accurate gestures and shapes.

I've used a drybrush technique to create the effect of fur on the dogs' coats—it's a technique that's useful for any rough textures you'd like to achieve, whether that's on trees and wildlife, or hair and furniture. See page 21 for more on how to use this technique.

The following steps will give a few specific details for each of the dogs, but always start by painting the base color of the fur, making sure it is a shade that's easy to layer with other colors. And finish by adding the details such as eyes, ears, and collars. You can then add in any toys, food, and accessories to fill in any gaps.

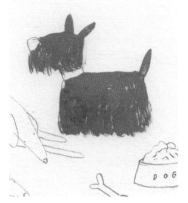
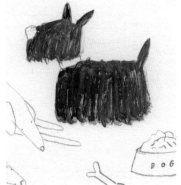
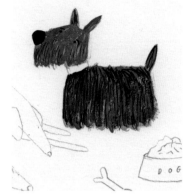

* Zinc white
* Ivory black
* Rose pink
* Flesh tint
* Cadmium yellow

SCOTTIE DOG

Mix a tiny bit of zinc white with ivory black together to create a medium gray and apply this as the base color, letting it fully dry before continuing. For the fur texture, mix a black or very dark gray with very little water and use your smallest brush to apply strokes in a downward motion using the drybrush technique. Cover the whole body and tail, and then apply texture across the bottom half of the head. This will mean that the eyes and nose don't get lost in the fur; you can use ivory black straight from the tube for these details. For the ears, I mixed a light pink using rose pink, flesh tint, and a touch of zinc white.

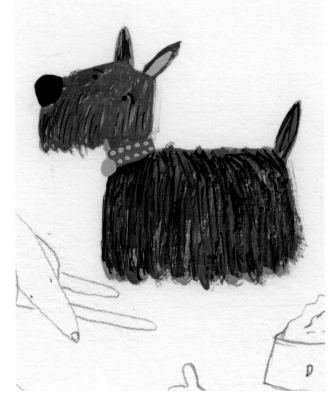

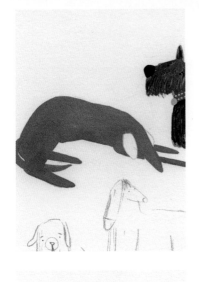

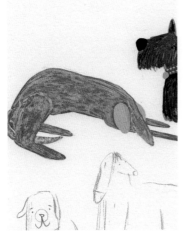

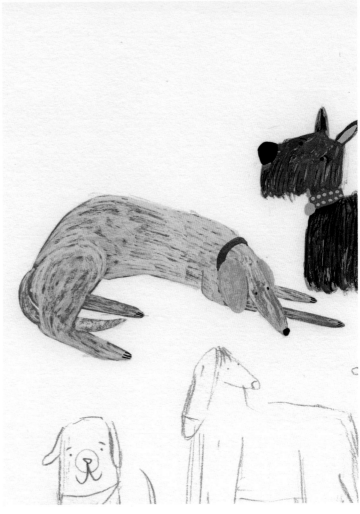

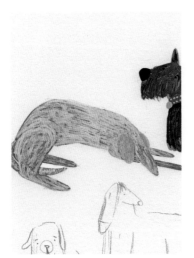

RETRIEVER

For the golden base color, mix yellow ocher with a touch of burnt umber. For the fur, add a touch of zinc white to the base color and apply with a dry brush. As the dog is laying down, apply the strokes horizontally. To differentiate between the torso and the legs, try to work with the shape of the leg and apply the dry paint in a round motion to show the contour of the body. Add more white to the paint and repeat the process to give the fur added depth and texture.

PALETTE USED

* Yellow ocher
* Burnt umber
* Zinc white
* Ivory black
* Turquoise blue

* Ivory black
* Zinc white

AFGHAN HOUND

You don't really need to paint a base color for this dog. Afghan hounds have long, luscious hair, so focus on thin brushstrokes. Using drybrush technique, apply brushstrokes that go from the top to the bottom of the dog. Next use your smallest brush to add in fine dark gray lines for the hair. You can add a bit of water into your paint at this stage to make the paint flow more easily. Finally, add some white highlights.

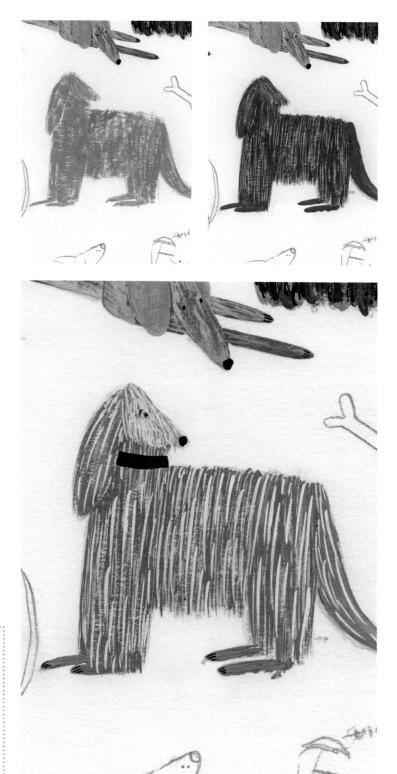

TIP

Adding a bit of white at the last stage really lifts the image and gives it some dimension.

BEAGLE

There isn't really any texture on this pooch, so after painting a light cream base color, simply mix up a rich brown by adding sap green and primary red together with a touch of yellow ocher. Apply a nice thick layer of paint to create patches on the body, face, and tail. Do the same using ivory black or burnt umber paint. Add a tongue with rose pink and zinc white.

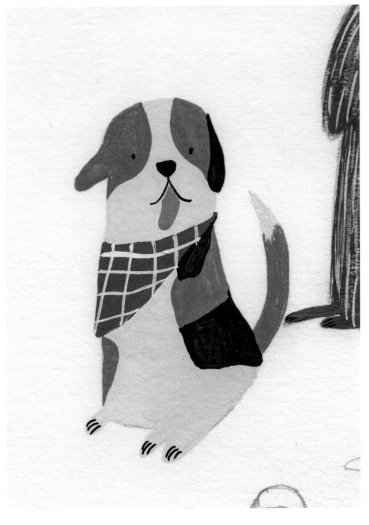

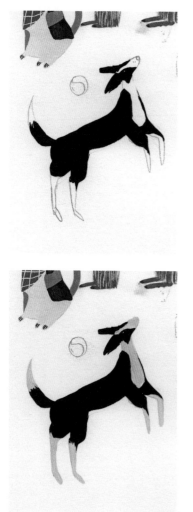

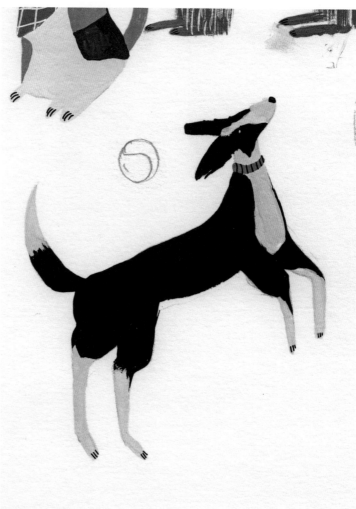

BORDER COLLIE

Use ivory black directly from the tube to ensure a deep shade for this dog's body; you will only be using two colors so it's good to get them to stand out against each other. Border collies are normally just black and white, but as the paper is white, it's a good idea to use a light gray to make it stand out. Apply this in the gaps that you left when applying the black paint, overlapping the edges where they meet roughly to look like fur.

PALETTE USED

* Primary red
* Sap green
* Zinc white
* Ivory black
* Rose pink

BORDER TERRIER

Brownish grays are the shades you're looking to mix for this scruffy little terrier, and really utilize the drybrush technique to portray its wiry hair. Mix up a brown with primary red and sap green, adding in zinc white until you achieve a shade that you're looking for. When applying the paint, leave space around the nose and mouth and the underside of the ears. Separate your brown paint into two, add a bit more zinc white to one half, and apply this new color to the nose and underside of the ears. Then add a tiny amount of ivory black to the other half and apply the paint in small flicks to give the impression of fur. Do this all over, and then repeat with the lighter shade of brown.

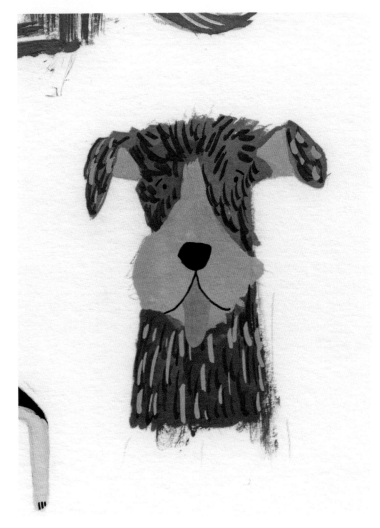

Lounging Cats

PALETTE USED

* Sap green
* Fir green
* Cadmium yellow
* Rose pink
* Red orange
* Zinc white

Unlike the individual dogs in the previous project, these cats are painted in situ, lounging at home. This is harder in some ways as you need to develop a complete composition and paint the cats in a way that makes them seem nestled and grounded within the scene. Try sketching out a few options before you settle on the final drawing. I recommend starting with something more straightforward such as a cat on a windowsill or sleeping on a mat.

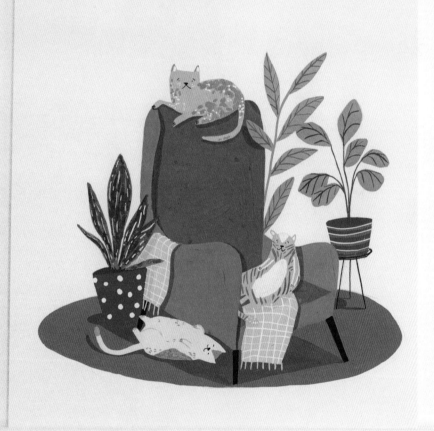

1 →

Pick a scene to set your cats in, I went for a cozy armchair, but you could set them anywhere in the house or even in a garden or urban scene. I've added in some potted plants to give some more interest and to help frame the central chair. You could think about adding elements that appeal to you such as a big pile of books or a side table topped with a pot of tea. Make the scene your own.

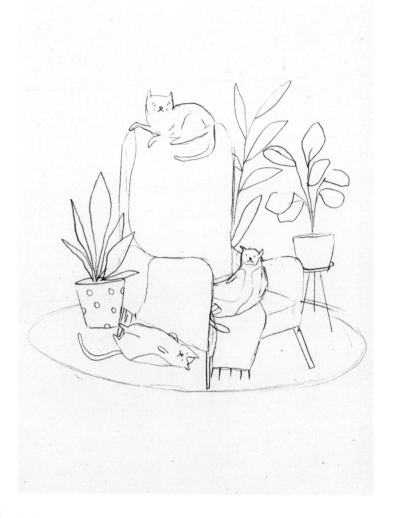

← 2

Pick your colors before you start. You'll likely use a lot of different colors, so test out a palette on a separate sheet of paper first to feel confident about the key shades, making sure they stand out next to one another. I've used a dark green to create a contrast with the light cream colors and to compliment the reds used.

Paint the main areas of your drawing, leaving spaces where your cats and any other lighter areas will be. For vibrant colors, apply a thick layer of paint. For the chair I mixed sap green and fir green, altering the shade for the arms and seat. For the blanket I used cadmium yellow, and for the rug I used a blend of rose pink, red orange, and zinc white.

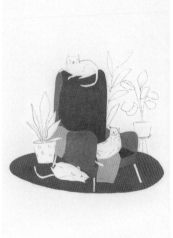

TIP

Add elements in the foreground and the background for a better sense of depth.

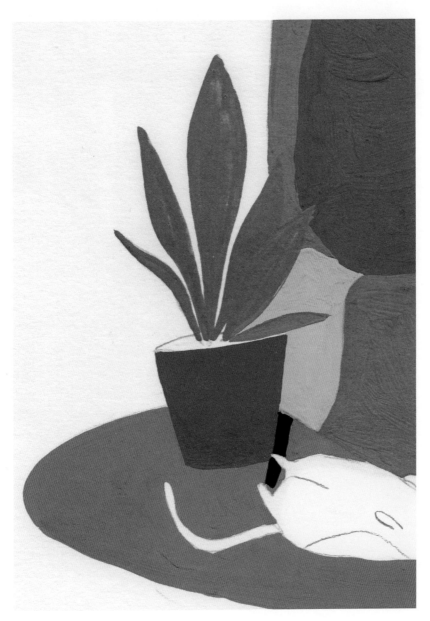

← **3**

Use a small brush to achieve the delicate shapes of the potted plants and mix sap green with some water to make sure that the paint flows easily onto the page. For the pots, I've added more red orange to the pink mixed for the rug.

4

Now for the cats! Paint the base color of each of the cats first and allow the paint to dry fully. Creams, light pinks, and light yellows all work well for cats and allow you to add fur and face details easily. Use your smallest brush to achieve the more delicate shapes and points of the ears and tails.

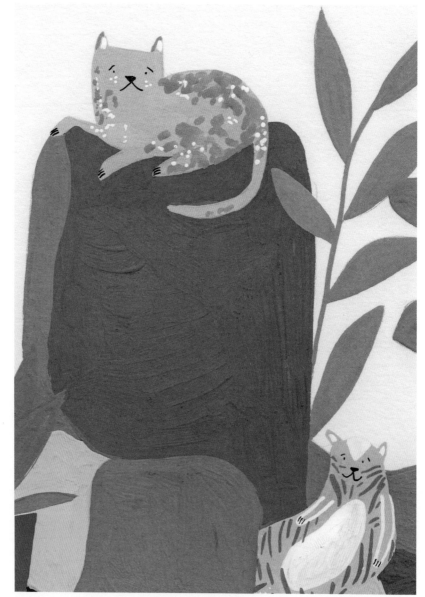

5 ↑

As you add the eyes, noses, and claws, be very light-handed with your brush as you don't want to apply too much paint. Don't overload the brush to paint the stripes and spots or you'll likely leave a dollop of paint behind. Vary your brushstrokes as you add these to achieve lines of different widths and lengths—no cat has perfectly even stripes.

6 →

Add extra details such as patterns on the leaves and plant pots. The leaves of the plant to the left of the chair have some added texture by mixing up a dark green and using a fairly dry brush to apply loose, random strokes and dabs. Once that's dry, use a very fine brush to apply some white lines to the blanket, again being fairly random but avoiding any touching lor overlapping lines. I've gone for a simple checked pattern—allow your hand to wobble a little for a more organic look.

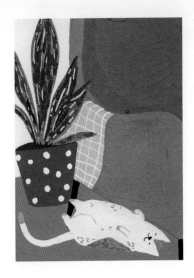

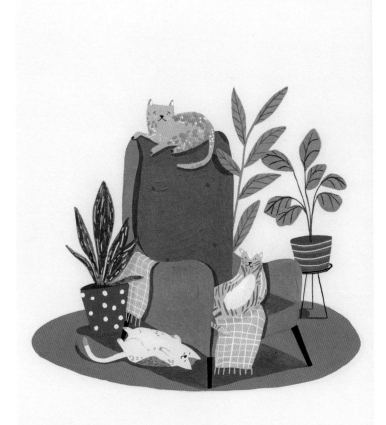

← 7

Finally, add in the shadow under the chair, cats, and plant pots. Do this by carefully mixing shades that are only slightly darker than the color you are painting on top of. Remember to look out for areas that will make subtle but effective differences such as the inside arm of the chair, the overlapping leaf at the top right of the chair, and under the cats' tails.

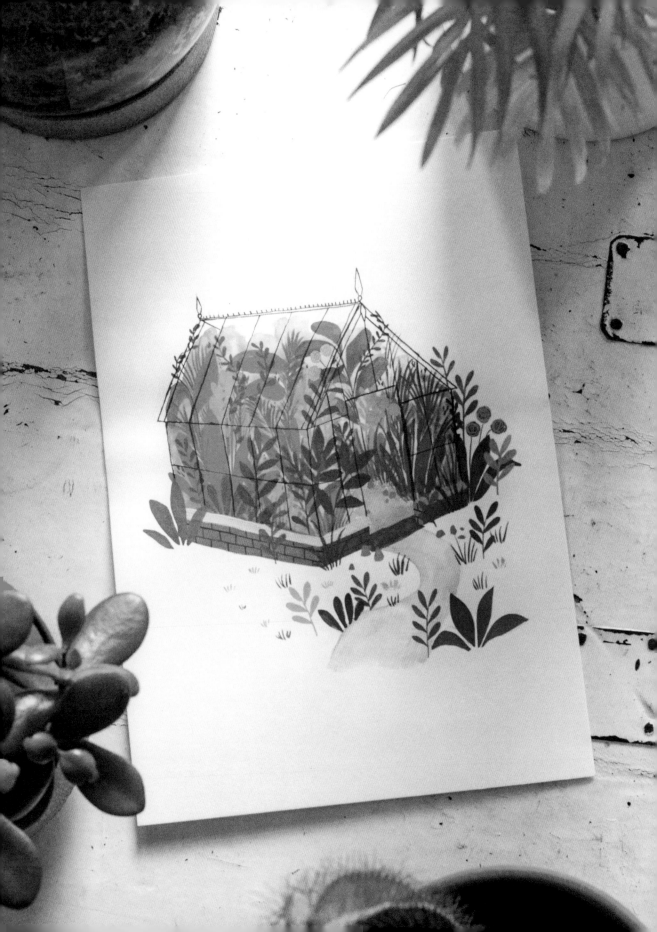

Greenhouse

PALETTE USED

* Fir green
* Sap green
* Permanent green middle
* Linden green
* Prussian blue
* Ivory black
* Yellow ocher
* Zinc white
* Red orange
* Rose pink
* Ultramarine

The focus of this project is the blooming technique (see page 23), which uses gouache like watercolor paint to create soft clouds of color that you can then apply dense gouache to in order to create a painting with depth and movement. A steamy greenhouse packed with plants is the ideal subject for this striking technique.

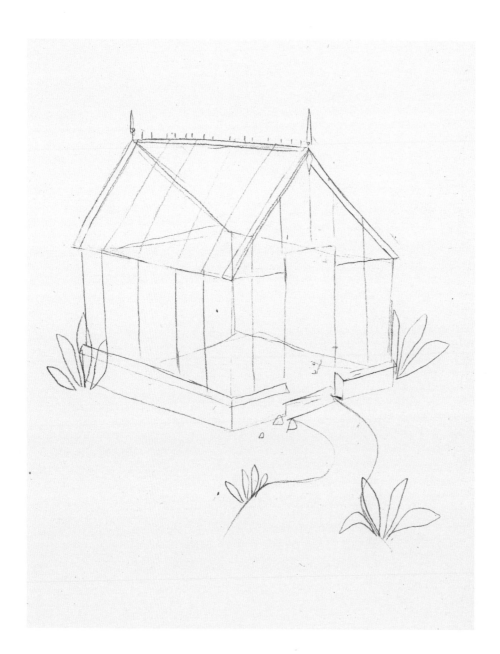

1 ↑

Sketch the basic shape of your greenhouse, adding some details around the main structure to help ground it in the painting. I've added a path, but you could think about a pond, grass, or a flower bed.

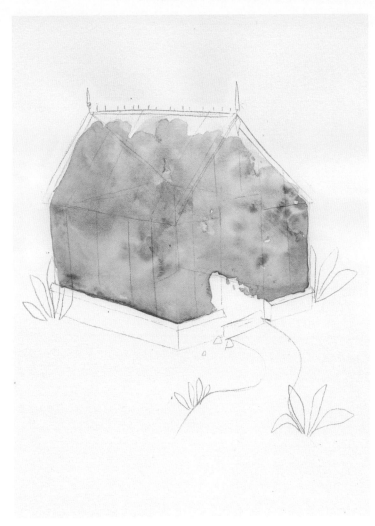

← 2

We'll be using the blooming technique for the base inside the greenhouse. Speed is important here, as you want the paper to be wet when you apply the paint. Have your paints ready and plan which colors you want to use. I've used a variety of different greens: fir green, sap green, permanent green middle, and linden green. To get each one ready you need to mix a very small amount of paint with a large amount of water on your palette.

To prepare the paper, use a large brush to cover the area inside the greenhouse with a wash of water. Then, before the water has had a chance to try, use a medium-sized brush to add different shades of green paints you've prepared onto the wet area on the paper. Allow them to bleed and merge into one another. Add darker greens around the edges and lighter greens toward the top.

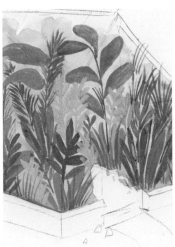

← 3

Once the paper has fully dried, you can paint your foliage. Use the same greens but less diluted. Paint a range of plants in different sizes and shapes. Use a different shade or color of green for each one to keep the plants from merging and to add interest. Try to keep the plants within the lines of your sketch, but don't worry if a couple of leaves stick out slightly as it will only add to the wildness of your greenhouse.

4 →

Using slightly darker greens, paint in some delicate vines and extra details. To achieve some good shades, add fir green into the permanent green middle or add some Prussian blue or ivory black to your already mixed greens.

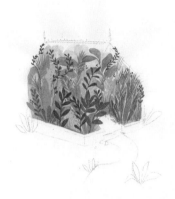

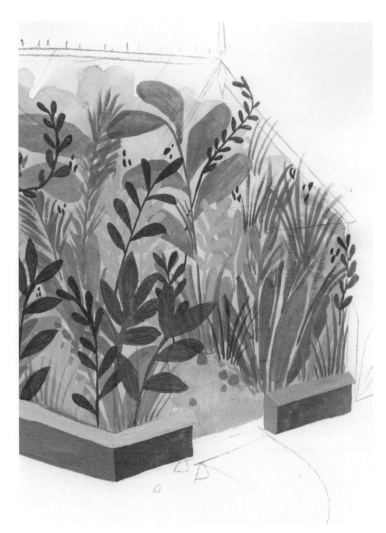

← 5

Now we can start building the greenhouse around the plants. I've used a sandy color for the ground within the greenhouse and the path, which is a mix of yellow ocher and zinc white. For the wall that sits around the bottom of the greenhouse, mix up a brownish gray color using small amounts of zinc white, ivory black, sap green, red orange, and yellow ocher. The top section was made by just adding more zinc white to this shade.

6 →

Add more water to your sandy mix, making it the same consistency as the greens used in step 2. Having a thinner, watery paint is helpful for achieving softer edges, ideal for a path that fades out of the scene. Use the blooming technique explained in step 2 to paint the path.

Next, paint the frame of the greenhouse. I've used red orange mixed with yellow ocher for a rich terracotta color, which stands out against the green leafy interior. Use a very thin brush to closely follow your sketched lines.

Add some ivory black to your brownish gray brick color to create a darker shade for the brick details around the bottom of your greenhouse.

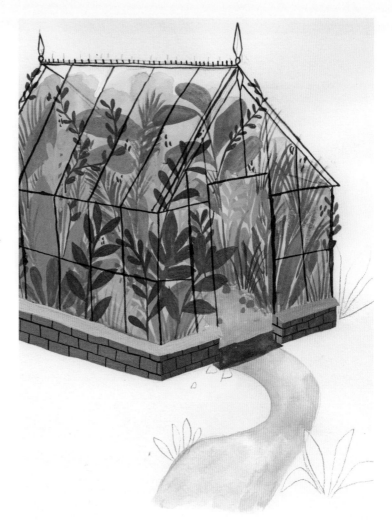

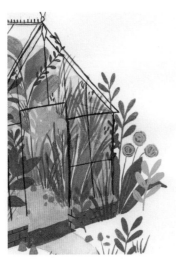

← 7

Lastly, inject another color. Add in flowers and any flourishes that you fancy. Pinks and purples look great next to green. I've mixed ultramarine, rose pink, and zinc white to get a lovely lilac color.

Jungle Swimming

PALETTE USED

* Indigo
* Permanent green middle
* Rose pink
* Zinc white
* Sap green
* Ivory black

In this project, you'll be painting on top of dark colors. The trick here is to use less water than normal when mixing colors, so that the paint is opaque, and to think carefully about which layer to paint first.

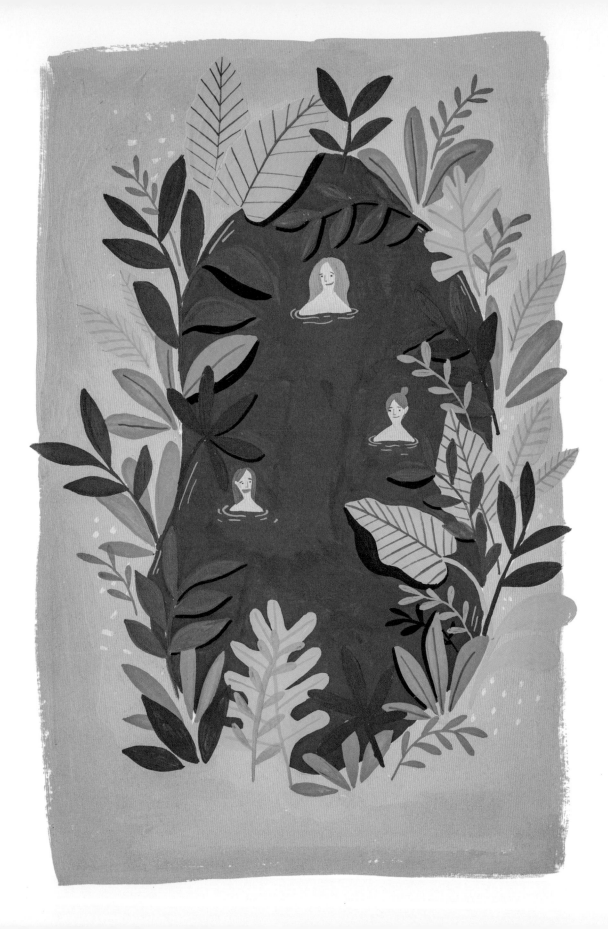

1 ↑

First, sketch out your design.
If you're including people in your
painting, go for an odd number as
it's more pleasing compositionally.
You can add to the jungle later,
but make sure you've drawn some
of the leaves and plants that you'll
be including.

TIP

For inspiration on leaf shapes, look at botanical
drawings and photographs online, or head to your
nearest botanical garden, park, or plant nursery.
Aim for fun shapes and lots of variety.

2 ↓

Choose two main colors and use them to
paint the water and background. I chose to
use a very dark teal (mixed from indigo and
a bit of permanent green middle) for the
water to contrast with the pink background
(rose pink mixed with zinc white). The dark
pool will also ensure that the people will
stand out. Leave white spaces where you
intend to paint your lightest subjects, as it
will be more difficult to paint them on top
of a dark color.

3 ↑

When painting foliage, it's best to work from light to dark, building up the detail as you move through the shades. Start with a light and vibrant green, which you can mix from permanent green middle and zinc white. Paint the large leaves first, it will make it easier to add the darker, smaller leaves on top.

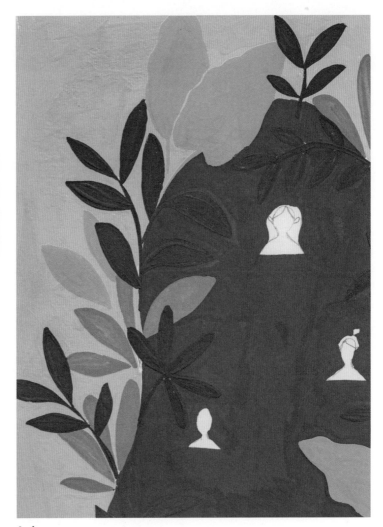

4 ↑

With a slightly darker green (permanent green middle mixed with sap green), paint the medium-sized leaves. Now mix an even darker green for the final leaves by adding more sap green to your mix or a tiny bit of ivory black. Remember to limit the amount of water you add to the paint when working on top of another color to help maintain a vibrant and opaque layer.

5 →

Paint in the bodies of your swimmers, but leave gaps for the hair. Again, make sure you use a thick consistency of paint. Once dry, add small dots for eyes, a thin pink line for the mouth, and small brown lines for the eyebrows. Mix a slightly darker shade of your chosen skin tones (see page 71) and add in the noses and the lines under the jaws to give the faces some definition. For the hair, simplicity is key; give your characters hairstyles in whatever color you want.

Mix a pale blue by adding a touch of indigo to zinc white. With your smallest brush, add in delicate lines around the bodies of your swimmers to show the water rippling. You could also add lines at the edges of the water.

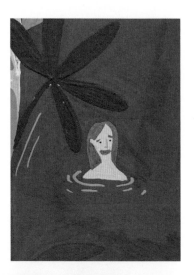

6 →

The final stage of this illustration is to add in shadows and any further details. Select the leaves that you'd like to add shadows under—I've gone for the ones casting a shadow on the water to help give the pool a sense of depth. Add a touch of black to your indigo and paint in the shadows following the shape of the leaf. Finally, paint veins on some of your leaves.

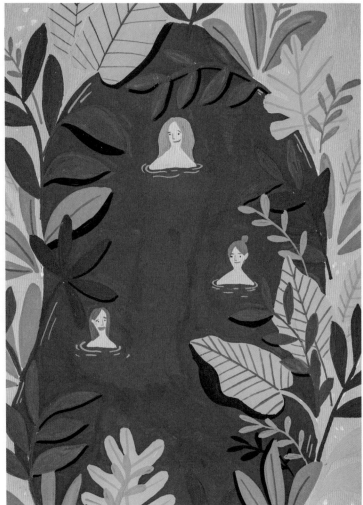

OTHER
IDEAS

PROJECTS

TOP TIPS: LEAVES

Leaves and plants come in so many wonderful shapes and sizes, which make them incredibly interesting to study and paint. Mastering the skill of painting leaves will make it easier to add foliage to your paintings whenever you want to.

Have a go at all the different shapes. Plants naturally have movement and are imperfect, so relax into it and don't worry about them looking perfect. Keep your hand loose and apply the paint with long sweeping brushstrokes to create the outlines—this will avoid them looking too rigid.

Experiment using both small and large brush sizes. With small brushes, you'll be able to create fine, delicate lines. With larger brushes you can achieve a more graphic look.

You can paint leaves using a range of techniques, varying from layering to blending. To use the blending technique, select three colors that are close to each other on the color wheel; I've used sap green with turquoise and ultramarine. I also mixed the turquoise and ultramarine together to create extra shades. Keep the paint fairly wet as this will allow the colors to mix with each other easily as you apply it to the paper.

Think of each leaf as two halves or parts. First apply the sap green, and then apply the second shade to the other side of the leaf, allowing them to meet. Once the colors have met, take a small amount of water and blend them together with a smooth downward stroke. You should see the colors blending together easily. Try this with different combinations of your color until you have a range of different-colored leaves.

Monogramming

PALETTE USED

* Fir green
* Zinc white
* Cadmium yellow

Personalizing your painting with
a decorative letter can be a simple and
effective way to create cards, artwork,
and stationery for yourself and friends.
You can use any motifs you like to bring
personality to the letters—if your friend
Fran likes figs, you could create a fruity
"F" or you could paint a "B" made up of
bike wheels for Ben, your cyclist friend.

TIP

Be slow and methodical, and step
back from the work regularly to
make sure that the definition of
your letter is still visible.

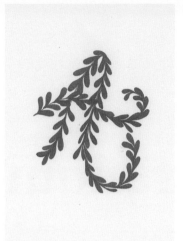

1 ↑

Lightly sketch out the letter you want to paint. This can be formal and rigid, or a curling calligraphic shape similar to the one I've drawn here. Make sure the letter is fairly large so that you have enough room to incorporate detail. Outline the letter in a base color using a thin paintbrush; I used fir green for mine. Keep your paint fairly diluted with water to make it easy to paint over in the next step.

2 ↑

Stick with your small brush and add a little zinc white to the fir green. Work in stages to add leaves to the line of the "A," creating a vine.

3 ↑

Add even more zinc white into fir green to make a light sage color, then add smaller leaves and details to the vines. This gives the letter more definition and interest. You can use any color at this stage, but I've decided to use a limited color palette.

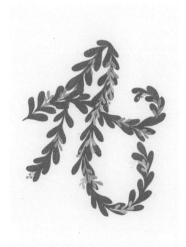

← 4

Lastly, pick your accent color. I've gone for cadmium yellow mixed with zinc white, but any color would work well here. Add in some small vines and tiny dots. You could also add flowers or buds into the letter. Again, keep stepping back from the work to make sure you're not overwhelming the letter with detail.

Magical Mountains

PALETTE USED

* Ultramarine
* Zinc white
* Sap green
* Yellow ocher
* Fir green
* Red orange
* Ivory black

Staining and blending are perfect techniques to employ when you want to create a scene with depth. To really emphasize this, your artwork should have elements in the foreground, middle distance, and distance—a landscape works very well for this. A simple trick for creating depth in a landscape is to have your objects grow lighter the farther away they are. For more on staining and blending, see pages 17 and 19.

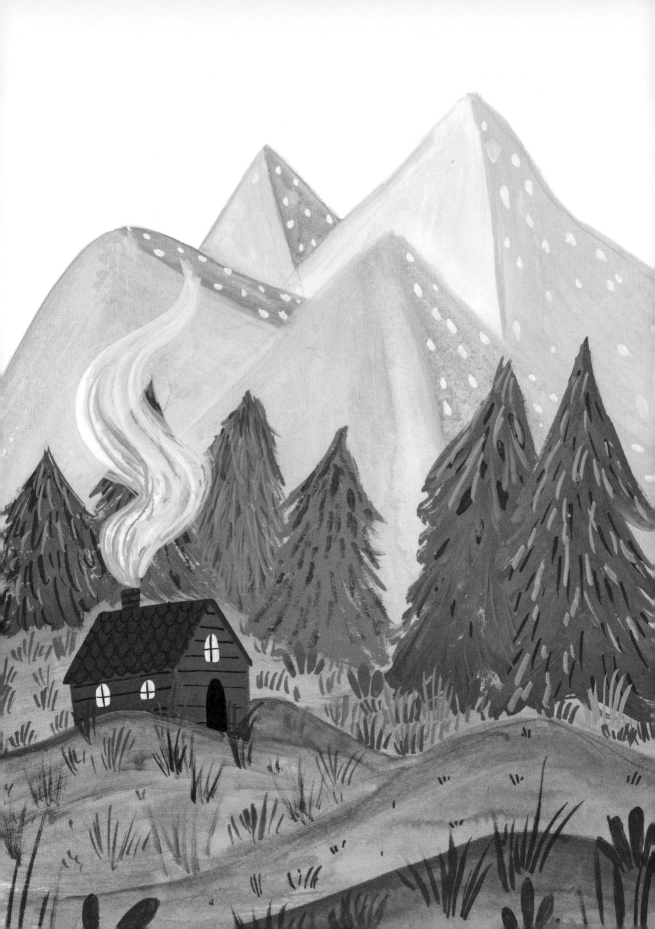

1 →

Sketch your chosen landscape; I've chosen a mountain scene. I've included a little cabin and some trees to help give a sense of foreground and backdrop. You don't need to overcomplicate this stage, as you can always add little details later on.

← 2

Start by staining the background. For the mountains, I used ultramarine mixed with zinc white and a lot of water. With a medium brush, paint a wash over the mountains altering between a slightly more or less diluted version of the ultramarine to get this nice light and dark effect to show the dimensions of the mountains. Let this dry before you move on to the green grassy section to avoid any unwanted blending of colors.

I made the grassy shade by mixing sap green with yellow ocher. Again, add lots of water to your paint, and apply in curved sweeping motions across the page to give the impression of rolling hills. You can add slightly more paint to get the darker areas at the tops of the hills and then add water to blend it down into the hill (see page 19).

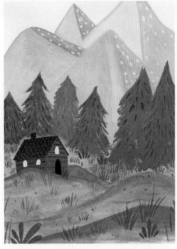
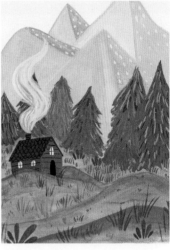

3 ↑

Use the drybrush technique to add the trees (see page 21). By allowing the bristles to leave their mark on the paper, you'll achieve a rough texture that's perfect for portraying the pine needles. Starting at the top, in a downward motion and flicking out to each side, paint the trees. I used fir green mixed with yellow ocher, and you can alter the color of each tree slightly by adjusting the ratios.

Using zinc white, add detail to your mountains. I've added some spots, but you can add snowy peaks or different patterns.

For the cabin, mix a brown from red orange, yellow ocher, and sap green, and for the roof add a touch of ivory black to the mix.

4 ↑

I think the little tufts of grass really make this piece. When working on something like this, always start light in the background and work your way through to dark in the foreground. Use a light green for the tufts on the hills, starting with the ones farthest away and adding a touch of sap green to the mix for the tufts as you move forward.

Mix fir green with a small amount of ivory black to add details to the trees, using downward flicking motions and a dry brush.

For the cabin, add in the windows with zinc white, then mix a dark brown by adding ivory black to the cabin mix, and add in details on the roof, windows, and sides.

5 ↑

One of the final touches is painting in the smoke from the chimney. For a translucent finish, return to the staining technique (see page 17). Mix up some zinc white with a fair amount of water and use a medium-sized brush to apply it in a sweeping motion. Do this fairly quickly to avoid disturbing the layers underneath too much. It will inevitably blend with some of the colors, but don't worry too much as it adds to the smoky finish.

Mix a light sage color by adding zinc white to your tree green, then add in some final details to the hills, trees, and smoke with a small, dry brush to make your painting pop.

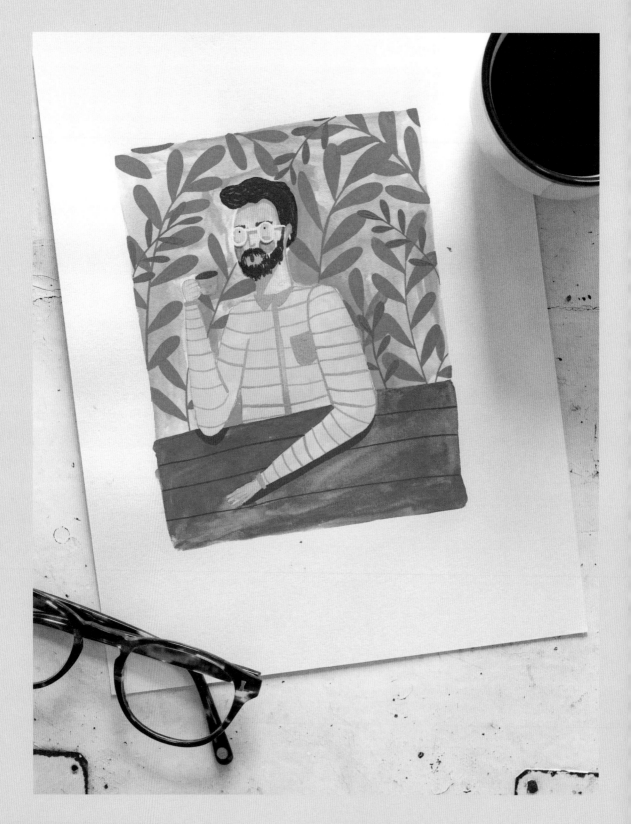

PROJECTS

Man with Mug

PALETTE USED

* Sap green
* Turquoise
* Zinc white
* Indigo
* Ultramarine
* Flesh tint
* Cadmium yellow
* Yellow ocher
* Red orange
* Rose pink
* Ivory black
* Fir green

The magical mountains project (see page 122) showed how the staining technique can give a scene depth and distance. It can also be used to create loose and painterly backgrounds that look like a bold watercolor but with a wonderfully chalky finish.

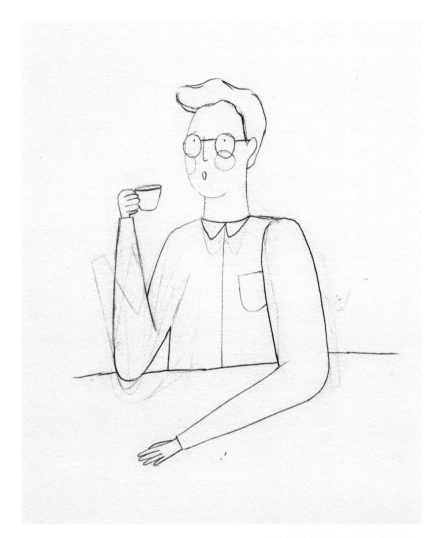

← 1

Sketch out your subject. I've gone for a man drinking a cup of coffee, but the idea is to have a subject or focus in the center of the image to allow you to play around with a stain for the background.

2 →

I chose cool tones for the background and foreground to contrast with the warm tones of the man's clothing and face. For the green, I mixed sap green, turquoise, and zinc white, and then added a lot of water to the paint. Use a large brush to apply this wet mix to the paper. For the blue, I mixed indigo and ultramarine before adding water. Apply in the same way as the background. Allow to dry fully.

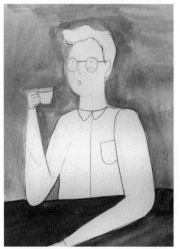

TIP

Don't worry if you go a little over the lines of the man; you can cover diluted layers of paint easily in later steps.

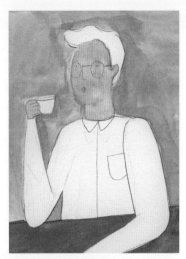

← 3

I mixed flesh tint with a small amount of zinc white and water for the skin (see page 71 for skin tones). Apply carefully with a small brush, making sure that no color runs over into the background.

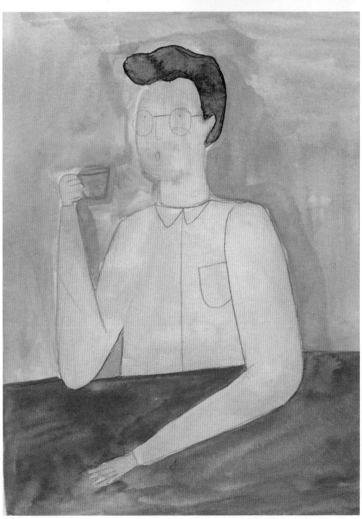

← 4

Still using the staining technique, block in the shirt, hair, and cup. I mixed cadmium yellow with lots of water for the shirt, and sap green, yellow ocher, and red orange with water for the hair. When painting two watery colors next to each other, allow one to dry first so that they don't bleed into one another.

MAN WITH MUG

5 →

Add the hair details and the pattern on the shirt. Mix cadmium yellow with yellow ocher to get a really nice deep yellow, then using a small brush, add in horizontal lines. For the dark brown, use sap green, yellow ocher, red orange, and a small amount of ivory black. You can then apply the paint in horizontal wiggly lines to the hair; keep your wrist soft for a more organic wobbly finish.

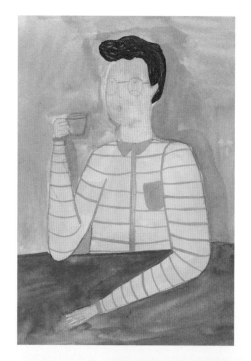

6 →

Now for the bit that everyone panics about: the face! First, add a shadow under the chin by adding a touch of rose pink to the color you used for the skin and painting an upside-down triangle under his chin, stretching up under his jaw. Paint an angular nose with the same color in the center of his face. Add two very small ivory-black dots for the eyes. Then use rose pink mixed with zinc white and water to add two translucent circles for each cheek and the mouth. I then used that same color for the inside of my mug to help tie the two elements compositionally. For the beard and eyebrows, use the same color that you used for the hair. I've added glasses with zinc white so that it stands out against the features. Before painting any overlapping elements, ensure that the first layer has fully dried so that you don't mix any colors on the page.

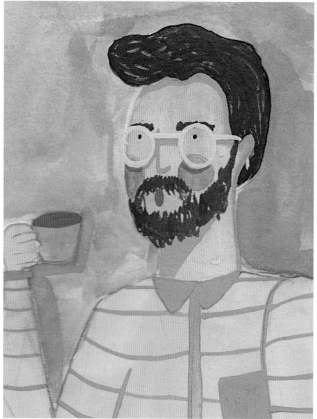

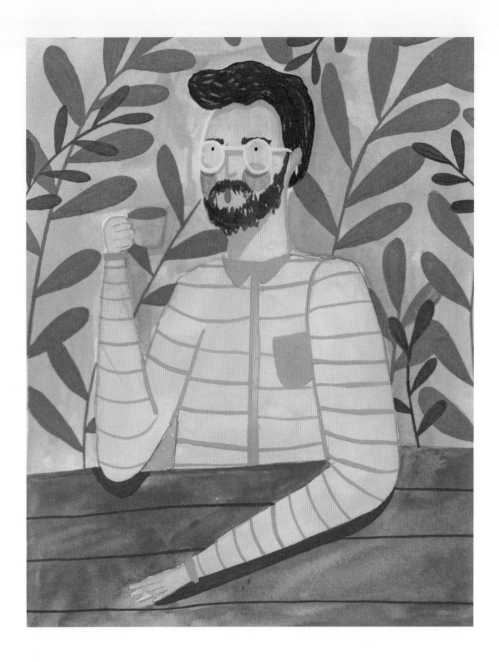

↑ 7

For the background, be creative! I've added leaves over the green stain in fir green. Keep the consistency of the paint fairly thick so that it covers the stain below.

You can also add in shadows under the arms on the table. I used ultramarine straight from the tube, adding a small line beneath the arms to look like shadow. Be careful here to not go over the sleeves or skin tone as this will be harder to cover up than the diluted paint used for the stain.

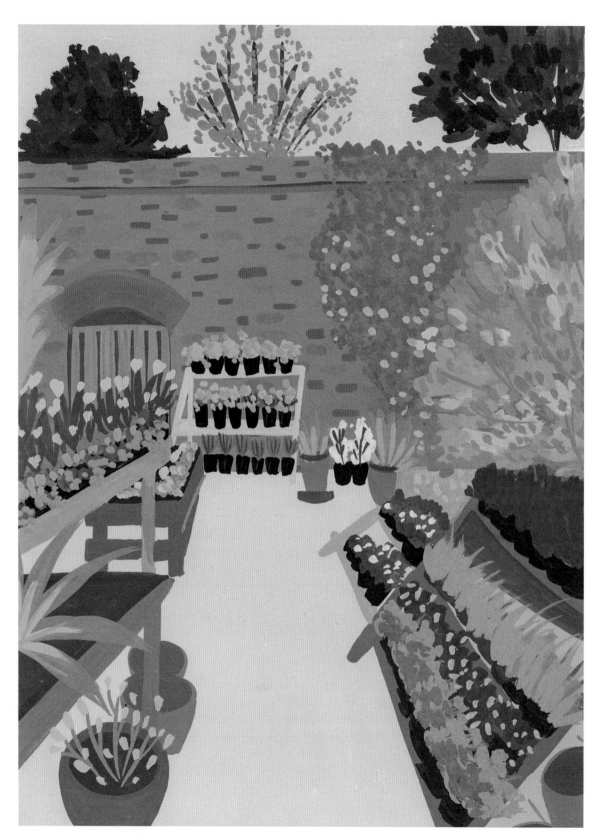

INSPIRATION FROM OTHER ARTISTS

INSPIRATION FROM OTHER ARTISTS

Painting is always going to be personal and the results will be distinctive to you, no matter which medium you use. I enjoy simple palettes, and have a fun, playful style with simplified shapes and tones, but this isn't the only approach you can take with gouache. Other artists use the medium to achieve completely different styles. Some like to use it similarly to watercolor, with a focus on blending and blooming, while others utilize the many colors and shades gouache has to offer. On these pages is a very brief selection of artworks by other artists using gouache, and I hope they demonstrate what a versatile medium gouache can be, and give you lots of inspiration to continue your painting journey.

ARTWORK Trelissick Garden
ILLUSTRATOR Lizzie-May Design

ARTWORK Misty Houses
ILLUSTRATOR Emma Carlisle

ARTWORK Adventurers
ILLUSTRATOR Vivian Mineker

ARTWORK Lost

ILLUSTRATOR June Digan

ARTWORK La Tarde Part 1
ILLUSTRATOR Natalia Vico

ARTWORK Butterflies
ILLUSTRATOR Jules Smerdon

INSPIRATION FROM OTHER ARTISTS

ARTWORK The Escapist

ILLUSTRATOR Jennifer Dahbura

INSPIRATION FROM OTHER ARTISTS 139

Index

Picture Credits

Ilex would like to acknowledge and thank the following artists for their permission to include their artwork in this book.

132 Lizzie-May Design, @lizziemaydesign; 134 Emma Carlisle, @emmacarlisle_; 135 Vivian Mineker, @vivian.mineker; 136 June Digan, @junedigann, www.junedigann.com; 137 Natalia Vico, @nat_vico; 138 Jules Smerdon, @julabulaart; 139 Jennifer Dahbura, El Salvador, @jennidahbura

Acknowledgments

I would like to thank the wonderful team
at Octopus Publishing Group for giving me
this opportunity and their continued support
throughout the creation of this book.

Also a massive thank you to my mum, dad,
sister, and Adam for pushing me thus far into
my career and always supporting me.